Painting **Buildings** *In Oil*

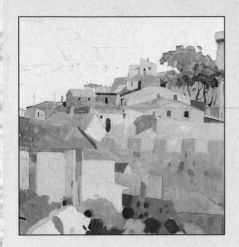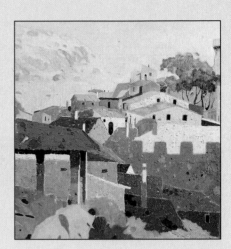

JOSE M. PARRAMON

Watson-Guptill Publications/New York

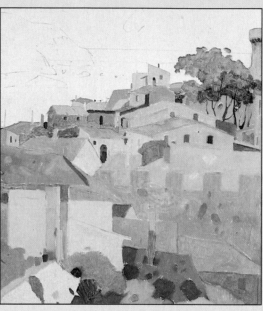

Copyright © 1990 by Parramón Ediciones, S.A.

First published in 1991 in the United States by Watson-Guptill
Publications, a division of BPI Communications, Inc.,
1515 Broadway, New York, New York 10036.

Library of Congress Cataloging-in-Publication Data

Parramón, José María.
　　[Pintando paisaje urbano al óleo. English]
　　Painting buildings in oil / José M. Parramón.
　　　　p.　　cm.—(Watson-Guptill painting library)
　　Translation of: Pintando paisaje urbano al óleo.
　　ISBN: 0-8230-3582-4
　　　　1. Buildings in art.　2. Painting—Technique.　I. Title.　II. Series.
　　ND1410. P3　1991
　　751.45'44—dc20　　　　　　　　　　　　　　　　91-11298
　　　　　　　　　　　　　　　　　　　　　　　　　　　　CIP

Manufactured in Spain
Legal Deposit: B-11.081-91

1 2 3 4 5 6 7 8 9 / 95 94 93 92 91

Painting **Buildings** *In Oil*

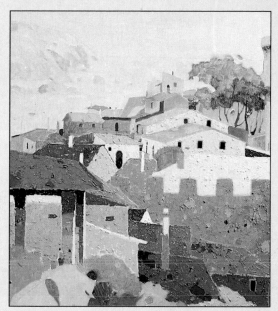
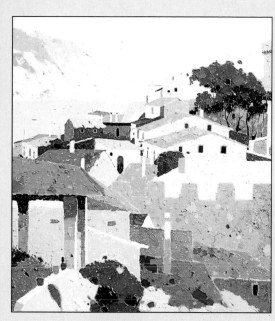

The Watson-Guptill Painting Library is a collection of books that guides the student of painting and drawing through the works of several professional artists. Each book demonstrates the techniques and procedures required to paint in watercolor, acrylic, pastel, colored pencil, oil, and so on, within a specific theme: landscape, still life, figures, portraits, seascapes, and so on. Each book in the series presents an explanatory introduction followed by lessons on painting that subject. In this book, *Painting Buildings in Oil*, the introduction explains the basic elements of composition, depth, and perspective. Each volume reviews the techniques, tools, and materials used for the medium in question.

Perhaps the most extraordinary aspect of this series is its comprehensiveness. All the lessons cover the choice of theme, composition, and color interpretation, as well as color harmony, the effects of light and shadow, color value, and so on. All this knowledge and experience—and, even more important, all the techniques, secrets, and tricks of several professional artists—all are explained and illustrated line by line, brushstroke by brushstroke, step by step. Each book is illustrated with numerous photographs taken while the artist was painting the picture.

I personally directed this work with a team I am proud of. I honestly believe that this series of books really teaches you how to paint.

José M. Parramón
Watson-Guptill Painting Library

The origin of the city landscapes

As we can logically assume, the theme of urban landscapes is directly related to landscapes in general. Landscape painting of any kind is fairly recent in our culture. For centuries painting often depicted people in action, usually in relation to religious themes; in other words, the figure was used as a symbol of other realities, such as myths and gods. Painting also depicted "heroic" historic deeds such as battles, coronations, victories, and royal visits.

During this long period, if there was a reference to city landscape, it was of a totally symbolic type: The landscape didn't represent any particular place, but rather stated an idea, such as city or country or sky. (See fig. 1.)

Then the city as such began to acquire its own importance. The working middle class became more important, and many of its members lived and worked in the cities. They began to commission artwork that represented daily life. Middle-class homes, rural landscapes, ordinary food, places of work, private portraits and also—why not?—the city and the town—gradually became the sought-after themes of the middle-class art buyer.

This change came about primarily in

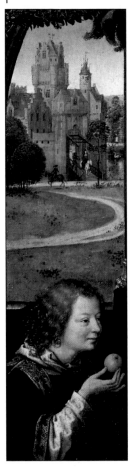

northern Europe, especially in seventeenth-century Holland, where landscapes acquired true independence and importance regardless of their lack of high symbolic content, thanks to the masters like Vermeer van Delft (1632-1675), Jacob van Ruysdael (ca. 1630-1681), Meyndert Hobbema (1638-1709), and Pieter de Hooch (ca. 1629-1685). It is here that we find the first pure landscapes, as well as the simple still lifes and the portraits of middle-class people in their rooms, or seen through windows and doors or at the end of a street. Here are cities and people just as they were: The artists have immortalized everyday life. Vermeer, in his marvelously peaceful paintings, introduced a realistic approach to the intimacy of middle-class life.

Fig. 1. Hans Memling (ca. 1430-1494) *Virgin in the Throne Between the Angels* (detail), Uffizi Gallery, Florence. The city is represented as a symbol of any city.

Figs. 2 and 3. Vermeer van Delft, *A View of Delft*, Mauritshius, The Hague. Pieter de Hooch, *A Woman and Her Maid on the Patio*, National Gallery, London. It was the Dutch, in the seventeenth century, who began to paint urban landscapes.

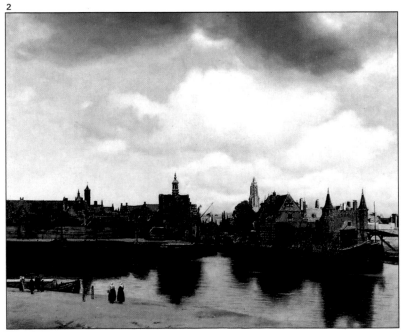

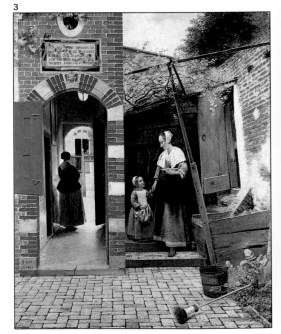

Eighteenth-century Italy: the Venetian painters

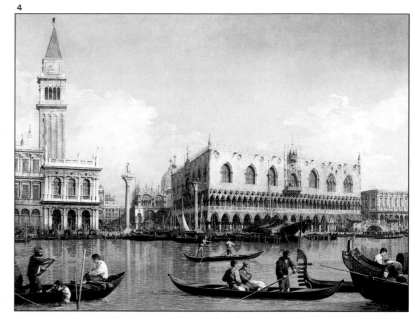

At the beginning of the eighteenth century, there had been no great changes in Italian painting since the Renaissance, although there had been some great painters such as Titian (ca. 1488-1576), the Veronese school, and Tintoretto (1518-1594). Giovanni Battista Tiepolo would come later (1696-1770). Now we're going to look at Venice in the eighteenth century and see its relationship to the painters we have just named.

Besides its economic and political decadence, Venice at this time was the center of luxurious living, and for this reason it continually attracted not only the curious adventurers, but also art lovers from all over Europe. The constant flow of tourists, as well as the aesthetic appeal of the city itself, created a flourishing interest in the landscape. Of course, the themes preferred by this likeable Venetian art form were the different aspects and views of this beautiful, harmonious canal city.

In a word: views, or *veduttas* in Italian. This meant painting the natural scenes that Venice had to offer. A city of singular beauty was represented delicately in paintings and etchings during a period when the middle class had risen to power and traveling through Europe was in fashion. For this reason, tourists loved to take with them souvenirs of their trip—that day's equivalent of photographs—views that captured the unforgettable impressions of the city bathed in water and light.

There were quite a few painters who cultivated this type of painting, but Giovanni Antonio Canal, nicknamed "Canaletto" (1697-1768), and Francesco Guardi (1712-1793) stand out. Their beautiful paintings—which are detailed, miniature, and perfect in composition—show all the knowledge of perspective and atmosphere that these artists inherited from Italian painting. It is interesting to note that they used the camera obscura, a device that the Renaissance painters invented by chance while looking for the

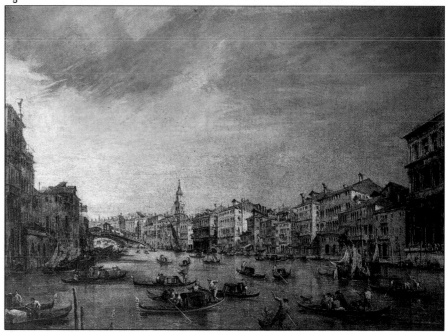

laws of perspective; it later became the forerunner of the photographic camera.

Tourists who visit Venice still collect views as much as ever, even though photography has replaced painting in providing souvenirs.

Figs. 4 and 5. Antonio Canal ("Canaletto"), *The Ships of St. Marks*; and Francesco Guardi, *The View of the Grand Canal of Venice*, both in the Pinacoteca de Brera, Milan. These two artists painted beautiful *veduttas* in oil in the 18th century, introducing the urban view as a new medium.

The impressionists: the rebirth of the urban landscape

Figs. 6 and 7. Claude Monet (1840-1926), *The Roman Bridge (St. Lazare Station)*, Marmottan Museum, Paris; and Edouard Manet (1832-1883), *The Emperors of Mosnier Street*, R.A. Butler Collection, London. The themes are crude: steamy trains and workers in the street.

Since we are interested in *urban* landscapes, we will take a big leap in history, leaving out the great historical painting period of the eighteenth and nineteenth centuries, and also the romantic period, which focused on landscape as creation's infinite and sublime symbol of man's impotence against the forces of nature.

We find ourselves at the end of the nineteenth century. The evolution of painting has continued. Changes have occurred as always, provoking or provoked by social, economic, and technological advances. As the industrial revolution marches onward, so does the revolution in painting, bringing with it a new attitude: The focus of interest is not so much in *what* is painted, but *how* it is painted.

We are speaking of the impressionists. They did their best to break with the tradition in which they were immersed and to create something new. Maybe for this reason they ignored imaginary, grandiose, unreal themes; like the Dutch of the seventeenth century, they preferred everyday common themes ("vulgar" as they were called in their day). For us it is difficult to judge their capacity for breaking away from the norm of their time, but their rebellion was so absolute that the people and critics who went to their first exhibits felt disgusted, cheated, and offended. Train stations, residential streets, workers, marketplaces, busy streets filled with traffic—these were not in any way considered picturesque. They were new themes, the realities of a new society. In 1876, one critic wrote:

"Peletier Street is a disaster. After the fire at the Opera House, another accident has occurred there. They have just opened an exhibit in the Duran-Ruel which, it is said, holds a gallery of paintings. I went there and my horrified eyes contemplated a frightening sight. Five or six lunatics, one of them a woman [Berthe Morisot], are exhibiting their work there. I have seen people breaking up with laughter in front of these paintings, but as for me, they broke my heart. These supposed artists consider themselves revolutionaries, 'impressionists.' They take a piece of canvas, color, and brushes, and they splatter it with haphazard paint stains and sign their name. We are reminded of the indolence of the insane who pick up stones from the side of the road and believe they have found diamonds."

The impressionists painted outdoors, and they painted what they saw. Their visions

6

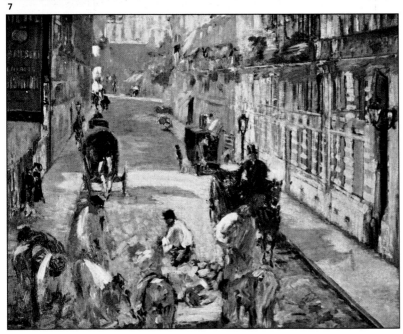

7

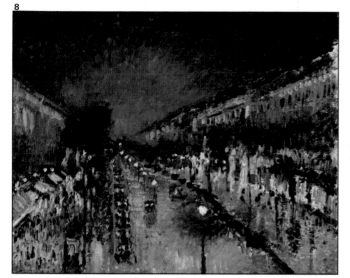

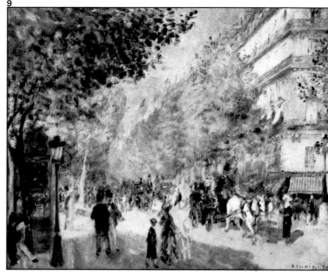

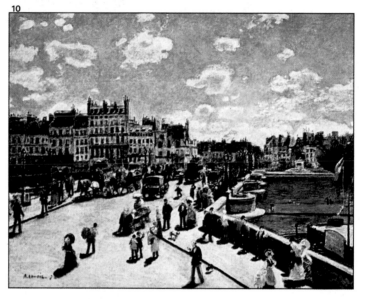

also changed: Those old paintings—balanced, composed in the classical style, without areas abruptly cut off—transformed themselves into paintings with a photographic point of view, with unusual frameworks, with broken elements intervening through the painting's overall effect. The light and the air were the most important; they might paint houses, but the houses at best were covered by trees, and the trees were not the theme either. What was important was the whole picture, the painting itself.

The impressionists and the postimpressionists painted still lifes, portraits of ordinary people, all types of landscapes, distant villages, and urban landscapes, all according to their revolutionary ideas. In fact, urban landscapes were one of their most important themes, if one can speak of important themes in impressionism.

And their attitude toward painting was inherited by all of the twentieth century, with several variations. We all know the enormous changes that characterize our century, but twentieth-century painting begins where the impressionists tried to define painting: Painting, before being a portrait or a landscape, is paint, stains, color. Urban landscape is one theme, intimate and common, that serves as an excuse to paint—as a motive for studying the ongoing problems of size, color, light, and composition.

Figs. 8 to 10. Camille Pissarro (1830-1903), *Boulevard Montmartre at Night*, National Gallery, London; Pierre-Auguste Renoir (1841-1919), *The Big Boulevards*, Collection of Henry P. McPenny, Philadelphia, and *The New Bridge*, Benziger Collection, New York. These are two impressionist painters who painted magnificent urban landscapes: cities at night, streets full of life, and views of very populated areas. These subjects are still painted today.

An important question: the third dimension

Let's now take a detour to the pictorial problems of painting urban landscapes, something we can do by studying some impressionist paintings more carefully. An urban landscape, like any other painting, deals with problems of composition, light, color, rhythm, and so on. Nevertheless, there are certain special problems characteristic of urban landscape painting: atmosphere and environmental effects, depth, vast subjects that occupy large spaces—and all this must be represented by paint on canvas or paper.

This entire question of depth, the representation of the third dimension on a flat two-dimensional surface, has several solutions that can be used simultaneously:
1. Superimposing levels
2. Atmosphere in the background and contrast in the foreground
3. Perspective

All three of these tools of the landscape painter will be further clarified in the next few pages.

Superimposing levels

When you look at a real landscape, you see many objects at varying distances from your eyes. An object close to you will look much larger than one of similar real size but much farther away, and this variation in *apparent* size helps you judge how close or far away each object is. This is especially true when you see close and distant things superimposed, such as a life-size man a few feet away from you and, just to one side of him, a tiny man several blocks away. (In a painting, if *all* the men you could see looked tiny, you might think they were meant to look like little dolls rather than men far away from you.) Superimposing objects at various distances from the viewer's eyes immediately establishes a sense of depth and makes the third dimension come alive.

An extreme example of this superimposing is the presence of an object that stands out in the foreground and superimposes itself on the middle ground and background. In this way, depth is dramatized even more. (See fig. 12.)

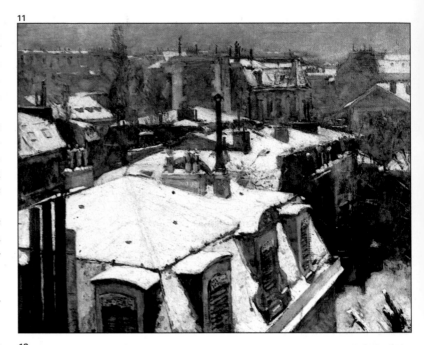

Fig. 11. Gustave Caillebotte (1848-1894), *Rooftops in the Snow*, Musée d'Orsay, Paris. Looking at this impressionist painter's work, we can clearly see his method of superimposing levels over each other to express depth. The rooftops, houses and chimneys overlap at times, and gradually become smaller as we look from the foreground into the distance.

Fig. 12. Gustave Caillebotte, *Paris Street: Rainy Weather*, The Art Institute of Chicago (Charles H. and Mary F. S. Worcester Fund). The composition of this canvas by the same impressionist painter ties in all the methods of expressing depth. The superimposing of the elements, the strong contrast in the foreground becoming vaguer in the distance, and the two figures close up that cover part of the subject—all these things help us to better identify relationships of size, distance, and depth.

Contrast, atmosphere, and color

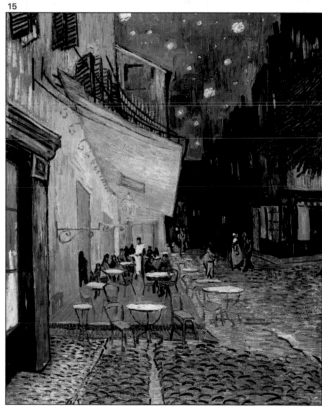

The representation of the atmosphere, the air that exists between things and helps us to see whether objects are close up or far away, became an obsession for Leonardo da Vinci (1452-1519), one of the great Renaissance painters. In his *Treatise on Painting*, he wrote: "If your work is very detailed, the objects in the distance will appear to be closer than they should. You have to attempt to imitate what you see very carefully, paying special attention to your distance from each object and the edges of the subject, where the borders are less defined. Represent them as they are; don't overwork them." For this reason, in his paintings, the figures seem to blend into the environment, and the landscapes seem even more to blend into the distant background.

Later this problem was resolved in various ways. For example, the impressionists were masters at synthesizing the idea of an atmosphere by blurring the undefined contours. (See fig. 13.) It's a matter of capturing light, color, and contrast between foreground and background. There are several basic principles to remember:

1. Objects in the foreground are more defined and have the maximum amount of contrast between light and dark, light and shadow.

2. Objects in the distant background blend into their surroundings; the colors mix together, more grays appear, and there is less contrast.

3. The warm colors (yellows, reds, ochres, siennas) tend to be more in the foreground; the cool colors (blues, violets, greens) tend to be more distant. (See fig. 15.)

Use these guidelines without fear, although every rule has its exception.

Figs. 13 to 15. Claude Monet, *St. Lazare Station*, Fogg Art Museum, Cambridge, Massachussetts; José M. Parramón, *Barcelona*, private collection; and Vincent van Gogh (1853-1890), *Outdoor Terrace at Night*, Rijksmuseum Kroller-Muller, Otterlo.

Perspective

"There are rules pertaining to proportion, light, and shadow based on perspective, which are necessary to know in order to be able to draw; if one doesn't know about these things it will be a constant and sterile battle and the desired results will never be obtained."

—Vincent van Gogh, *Letters to Theo*.

The conic perspective is what interests us, since it is the representation of objects with their three dimensions over a two-dimensional surface. In other words, it reproduces the illusion of real space on a flat space: the canvas.

As Rudolf Arnheim says, "The enigma of representing radical perspective is that in order to show objects as they are (to our eyes) it is necessary to make them as they are not."

The urban landscape, as we have said, is a theme that requires a painter to know the basic laws of perspective. Nevertheless, it is necessary to remember that if we paint outdoors and we know how to observe and relate things, only the basic minimum of knowledge is necessary. The absolutely indispensable can be summed up in a few pages, and this is what we're going to do now.

The basic ideas are:

Horizon line: This is always found directly in front of us, looking straight ahead, and at eye level.

We have the clearest exemple of the existence of this line when we look at the sea, straight ahead and without moving the eyes: it is the line formed by the meeting place between the sky and the sea. Even if you bend down or climb a rock, the horizon moves with you, and it is always at eye level.

Point of view: This is found on the horizon line, in the center of the viewer's vision—in other words, directly in front of you. This doesn't mean that we have to put the point of view in the middle of the painting, as you will see if you stop to observe the photograph on the opposite page.

Vanishing points: The vanishing points, always situated on the horizon, are where parallel lines appear to meet. The conver-

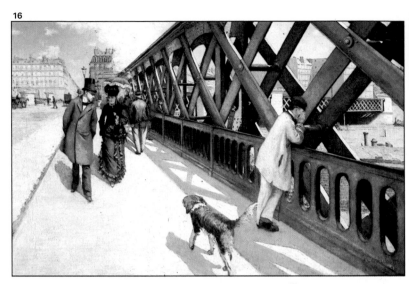

gence of parallel lines toward one or more vanishing points creates depth in a drawing.

According to how many vanishing points there are, we have three principal types of perspective:
1. One vanishing point means parallel perspective.
2. Two vanishing points mean oblique, or angular, perspective.
3. Three vanishing points mean aerial perspective. (This last one is hardly used in artistic drawing, so we will leave it out here in our brief explanation.)

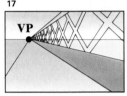

Figs. 16 and 17. Gustave Caillebotte, *The European Bridge*, Little Palace Museum, Geneva. This painting helps us feel depth thanks to its correct perspective, which you can study in the adjoining diagram.

Fig. 18. Perspective Model. M: model. HL: horizon line. PV: point of view. VP: vanishing point. PP: picture plane. VL: vanishing lines.

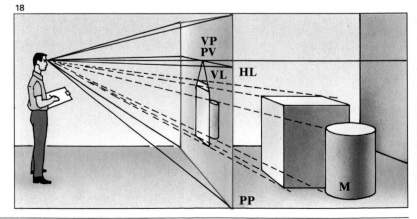

Parallel perspective

The cube is a very good form for representing the problems of perspective. For this reason a photographic image that includes a group of cubes will serve as a good model for explaining first parallel, then oblique, perspective.

In the first place, we position ourselves on the horizon line and imagine that the cube is above it (it could also be below). One characteristic of parallel perspective (which gives it its name) is that one face of the cube is in front of us, so that we see

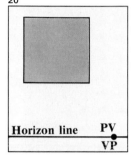

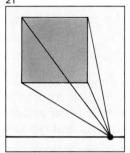

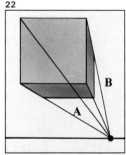

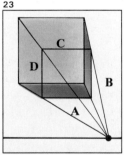

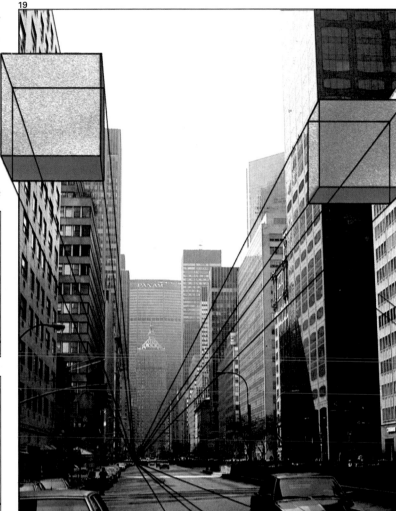

it without any type of distortion. Another characteristic is that the point of view is also the vanishing point.

Therefore, we draw one of the cube's faces, in front of us, with no distortion: it's a square, not more or less (fig. 20). The second step is to draw four lines that run from the four corners of the square to the vanishing point (fig. 21). Now we draw horizontal line A, establishing by eye the lower edge of the back of the cube (fig. 22). Next we draw the vertical B, completing the shape of the cube. But we still draw lines C and D, as if the cube were made of glass, in order to check the cube's correct proportion (fig. 23).

Now, if you observe the photograph of Park Avenue in New York City, a typical example of parallel perspective, you can check that all the parallel lines of the windows and doors merge in an orderly fashion. (In other words, they are converging toward the vanishing point.)

Fig. 19. In this photograph taken in a New York street we show the horizon line and the vanishing point in order to demonstrate with cubes how to draw anything within this particular perspective.

Oblique perspective

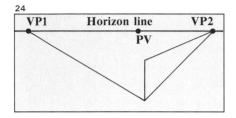

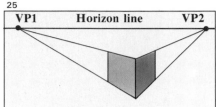

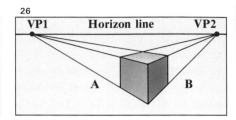

In oblique perspective, where we have two vanishing points, none of the sides of the cube are facing us; therefore, they all seem deformed. The intersection of *two* sides faces us instead, and since that is all we can see correctly, from it we begin to draw our cube.

We are on the horizon line, which contains the point of view and the two vanishing points, one closer to the point of view than the other (fig. 24). We draw the intersection closest to us, like a straight vertical line, slightly separated from the imaginary point of view (fig. 24). Next we draw the vanishing lines to the right and left, and we draw by eye the two sides of the cube (fig. 25). Now we draw the vanishing points corresponding to the new edges we have just added, and the upper side (fig. 26). Also we can draw the invisible vanishing points of the cube, as if it were made of glass. Be aware of an important factor in order not to deform the cube excessively: the angle constructed along the base of the cube must always be greater than 90 degrees.

The photograph on this page will help you understand what function this perspective has. In this case, the vanishing points remain outside the image and also outside the page, but they exist. You can check by extending these lines until they meet the horizon.

Fig. 27. In this photograph we are again showing the horizon line, which is at eye level, and we have extended and marked again the direction of the parallel vanishing lines on both sides of the house. The vanishing points don't fit on the page, but you can look for them the way we have indicated. The superimposed cubes give us the idea of how to see an object situated in this perspective.

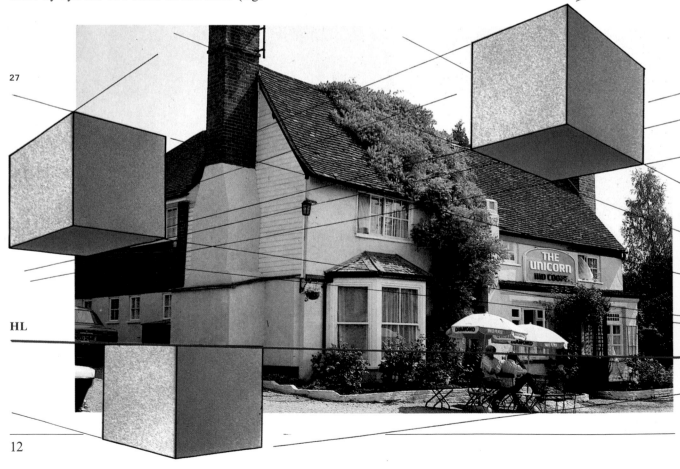

Guidelines

The problem that we have just proposed—the fact that one or two of the vanishing points remain outside the space of the paper when we draw in oblique perspective (fig. 27)—has a practical solution that we will explain by way of several examples. Above all, when we draw from memory, if the vanishing points are outside of the paper, it's difficult to establish the correct perspective for the walls, windows, doors, chimneys, roofs, and so on.

For this reason, we suggest establishing a system of guidelines to clarify the perspective for subjects of this type. Study the drawings that show how to construct these guidelines.

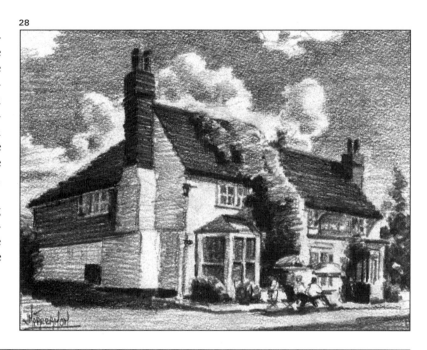

28

Fig. 28. When you are drawing or painting a subject in perspective like this, where the vanishing points are located outside of the picture, it is necessary to calculate the meeting point of the lines by eye. However, guidelines like those shown below resolve basically all the problems.

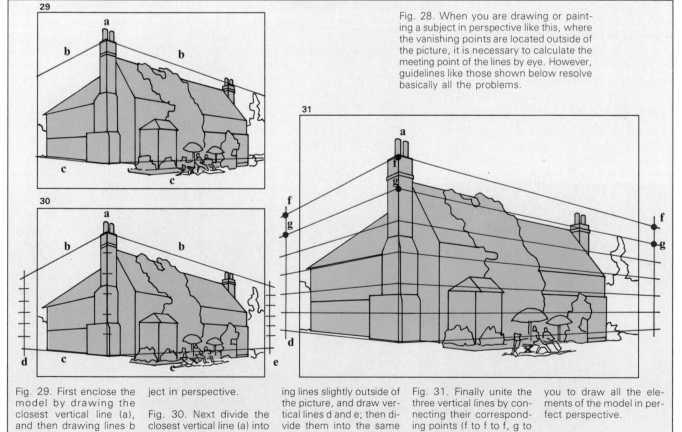

Fig. 29. First enclose the model by drawing the closest vertical line (a), and then drawing lines b and c, which define the top and bottom of the sub-ject in perspective.

Fig. 30. Next divide the closest vertical line (a) into a number of equal segments. Extend the vanish-ing lines slightly outside of the picture, and draw ver-tical lines d and e; then di-vide them into the same number of equal segments as line a.

Fig. 31. Finally unite the three vertical lines by con-necting their correspond-ing points (f to f to f, g to g to g, and so on). Guide-lines like these will permit you to draw all the ele-ments of the model in per-fect perspective.

13

The subject: a panorama of Barcelona

It's a sunny morning in the month of July. The appointment is at ten o'clock, and we arrive just in time. Montserrat Mangot, the painter, is already there. She is waiting for us at the lookout point of the mountain next to the port, where she has decided to paint (fig. 32).

Soon we discover why she has chosen this spot. From here she has a splendid view of the avenue, which disappears into the horizon with the port and the sea on the right (fig. 33). Parisian boulevards come to mind immediately, painted by such impressionists as Monet or Pissarro. They gave the urban landscape theme the rank of an artistic medium. (See fig. 34.)

We're in luck because it's a nice day for painting, and there's none of the fog that's been so typical lately. (Even if it were foggy now, the fog would disappear as the morning advances.) We mention to Mangot that the sun is climbing higher, rapidly changing the colors and shadows in the view below. She explains that this doesn't bother her much, but rather it provides her with even more variety of color in what she is about to paint. Mangot adapts and takes advantage of the conditions imposed upon her by outdoor painting.

33

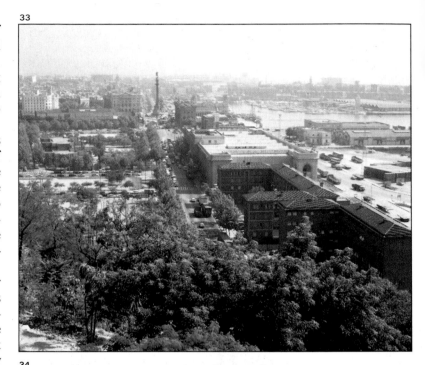

34

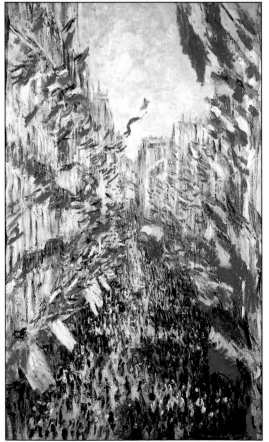

32

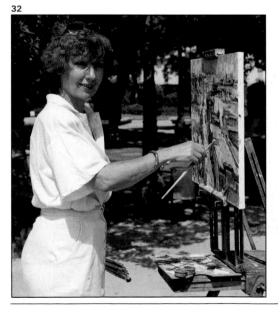

Fig. 32. Montserrat Mangot, a painter who has had numerous exhibitions and obtained various prizes, appears here painting an urban landscape in oil for this book.

Fig. 33. This is the subject that Mangot is going to paint: a broad panorama of a port and the avenue that runs alongside it. The avenue loses itself in the horizon, which at this hour of the morning seems erased by the fog.

Fig. 34. Some of the best-known paintings of the impressionists were done outdoors, *en plein air*. This type of painting uncovered the streets, the buildings, the stations, and the ports of the cities as valid subjects for artists. This was the birth of the theme we now call urban landscape.

Samples of Mangot's work

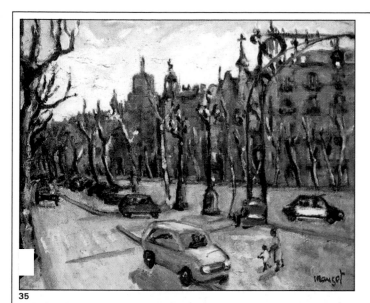

35

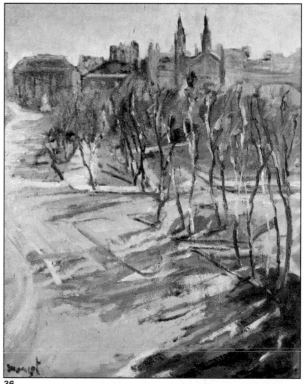

36

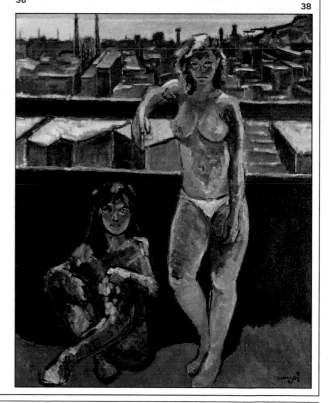

38

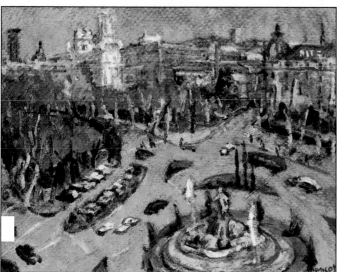

37

Figs. 35 to 38. Without doubt, the urban landscape is one of Montserrat Mangot's favorite themes, if not her only one. As you can see, she also paints figurative paintings, although in this particular example the figures are integrated into the urban background.

A brief overview of her paintings permits us to point out some of the characteristics that distinguish her work. The vibrancy of her paintings downplays the subject's details in the interest of color. Mangot's colors are intense, occasionally even burning, and her brushstrokes are strong and decisive.

The materials

Mangot opens a classic country easel-paintbox and places it without worrying about the sun and its angle of incidence on the canvas. Her canvas is 20×24'' (50×61 cm), which in Europe is called a figurative number 12 canvas. "I prefer this to the more oblong format often used for landscapes," Mangot explains. The canvas is surprisingly smooth, if we keep in mind the expressionist tendency of her painting, which suggests a much rougher surface.

Mangot fills both oil containers with turpentine, the only thinner she uses. Later she prepares the colors on her wooden palette, which is smaller than what normally corresponds to the country easel she uses.

The first thing that we notice is the reduced selection of colors. There are only six, without black: titanium white in the upper left corner; on its right three warm colors, cadmium yellow, cadmium orange, and Titan pink (comparable to English red); under the white two cool colors, ultramarine and emerald green. The sober palette announces what will be a master lesson in how to achieve a wide and varied range of tones from primary colors like yellow, crimson (or Titan pink), and ultramarine, to which green and cadmium orange are added (fig. 40).

Mangot takes various brushes from the aluminum box where she keeps her tools. Her filbert brushes are horsehair, with very short bristles. "No! No!" Mangot tells us, "they are flat brushes. What happens is that I like the cat's-tongue shape better, so I cut them myself."

Almost at once, Mangot surprises us again with an act that we can't qualify as habitual: She uses smoky, blue-tinted glasses. "They not only protect my eyes from the sun, but also provide me with a general color harmonization for the subject."

39

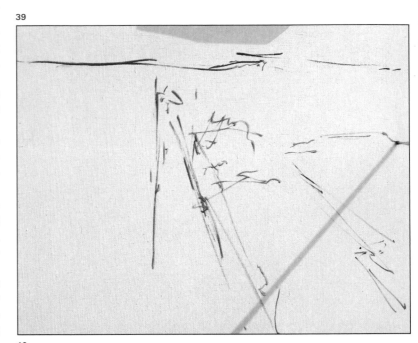

Fig. 39. With a number 12 brush she begins to draw and define the subject. Immediately, with a few lines of Titan pink, she establishes the basic axis of the composition and resolves the perspective.

40

41

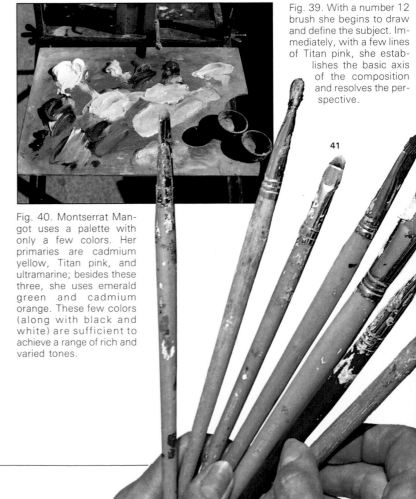

Fig. 40. Montserrat Mangot uses a palette with only a few colors. Her primaries are cadmium yellow, Titan pink, and ultramarine; besides these three, she uses emerald green and cadmium orange. These few colors (along with black and white) are sufficient to achieve a range of rich and varied tones.

First stage: starting with perspective

Mangot prepares to attack the canvas. With a well-used brush she takes a little Titan pink. Hardly raising the brush from the canvas and with a technique of rubbing hard, which is sometimes called the dry-brush technique, she draws lines that determine the basic axes of the composition. The horizontal line positioned at the top and the vanishing points of the central avenue organize the composition.

Mangot constructs the perspective intuitively, without showing any type of calculations, but with efficiency. Nevertheless, this apparent ease requires a knowledge of perspective that only careful study and constant practice can provide.

With a warm gray tone—a result of mixing ultramarine, orange, and white—she reinforces the horizontal axis and achieves the base of what will be the farthest point in the background. Alternating the positions of shadowed and light areas along the vertical axis, in a similar way, she succeeds in

placing what will be the central point of the painting. It's not so much a question of drawing as of achieving atmospheric effects, "ethereal," as she says.

Her rhythm is frenetic, very fast, like a kind of fever. Mangot grabs the brush in a peculiar way, so that it transmits every intention of her mind, every movement of her arm, to the canvas.

Figs. 42 to 44. Mangot stains the horizon area with a warm gray. With the same brush she defines the shadows of the buildings on the right (fig. 42). Contrasting the cool areas, Mangot paints the illuminated shapes of the streets with warm colors, dragging the color over the canvas (fig. 43). The painting acquires a sketch-like state (fig. 44).

42

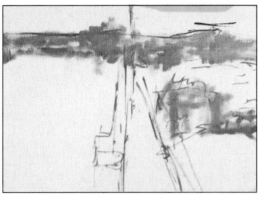

43

44

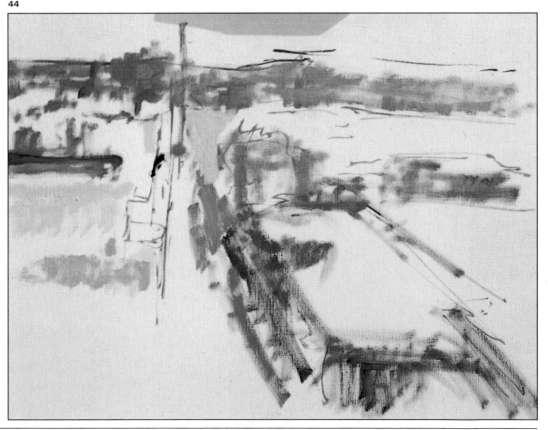

Fig. 41. Mangot keeps her painting supplies in a special aluminum box. She uses only turpentine for thinner. It's interesting, her habit of cutting her brushes into "cat's-tongue" or filbert form. "I like to paint with the tip of the brush, with the hairs clipped and cut short," Mangot says.

Second stage: a feverish painting

The way in which the painting advances makes it difficult to see its exact phases of development. Along with the velocity of its execution it is necessary to describe the indiscriminate approach with which she attacks the different parts of the painting.

To start with, she centers her attention on the trees along the avenue, using emerald green mixed with white for the illuminated areas (fig. 45) and with orange and blue for the shadows. Suddenly her hand jumps and moves to the left, where a dullish stain appears; it seems that she wants to define the shape of a building, but soon she changes the idea and begins to paint the area that corresponds to the sea (fig. 48).

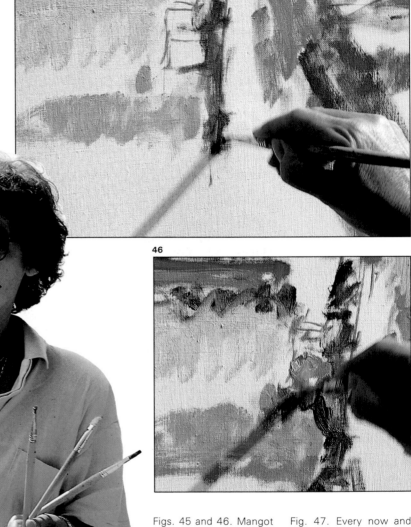

Figs. 45 and 46. Mangot paints everywhere at once. With a dirty green she determines the forms of the trees on the avenue (fig. 45). Immediately afterward she paints the adjacent light area with a pink tone.

Fig. 47. Every now and then, Mangot appears to be ''possessed'' with her painting and holds a brush between her teeth, as shown in this photograph.

Next she moves to the sky but doesn't finish it. She decides to return to the central axis, the avenue. Without changing her brush, she lightly paints a violet base, which she covers immediately with more paint of a pinkish tone.

She now makes the brushstrokes thicker. Mangot rubs the brush on the canvas, mixing the colors directly upon it rather than on her palette first.

For one moment during this creative fever, she raises a brush to her mouth, holding it between her teeth, while her left hand holds the rest.

Now Mangot looks at her subject squinting, and returns to the painting. "I always squint my eyes," she says, "trying to see general areas and to bypass the details; I paint with general areas more than shapes." In this rapid coming and going, alternating the vision of the subject with her vision of the painting, she captures the essence of shapes and colors.

Fig. 48. In this moment, Mangot's intention is to cover the white of the canvas, quickly establishing the basic color tendency in each area. The sea, she decides, should be a light blue-green.

48

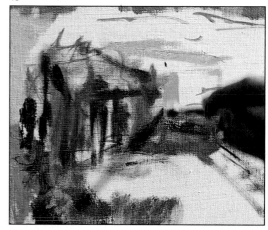

49

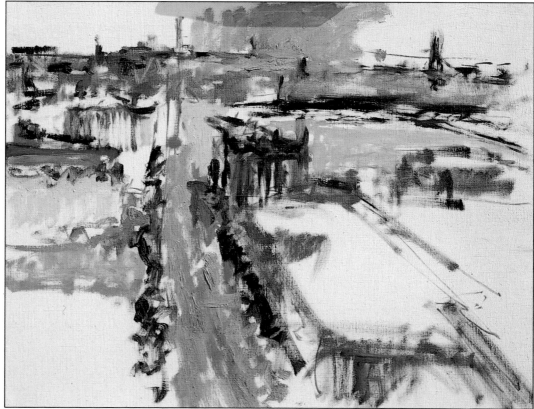

Fig. 49. The painting begins to take on shape within a diversity of color stains, which are a result of Mangot's own personal interpretation but always suggested by the subject itself.

Third stage: synthesizing the subject

Mangot creates space and defines the bulk of the shapes by applying a light, luminous tone over the dark tones that serve as the base. The painting progresses in this way, gradually gaining luminosity.

"This technique of painting light over dark," Mangot explains, "obliges me to submit the model to a rigorous session of synthesis, leaving behind any useless details that could hinder my intentions of summarizing shapes and colors." While she talks, Mangot paints the lower right-hand side of the building in the foreground, as an example of what she says (figs. 50 to 53). First she marks the boundaries of the basic structure with dark lines drawn decisively. Next she establishes the building's bulk by painting its roof with a yellowish tone that contrasts with the shadows of the building's side walls. Then she immediately defines the shadow projecting on the left with a bluish tone (fig. 54), and finally, with some orangish brushstrokes, she paints the area on the other side of the building, which you can see in the far right of figure 55.

After resolving this part of the painting, Mangot returns to work on the sky. Starting with a dull color, tending toward crimson and coming from English red, the painter adds bluish and yellowish shades. In this way, the sky has become enriched with a variety of color tendencies that give the impression of a slightly foggy atmosphere in the distance.

50

51

52

53

Figs. 50 to 53. Mangot's painting technique ignores details but tries more to define colors and shapes. Now she paints the low, flat building in the foreground. First she determines the shadows and outlines of her structure (fig. 50); then with the same brush she paints the lights above the dark stain at the base (fig. 51). Next she mixes, right on the canvas, the pink base with a yellow tone in order to achieve more luminosity on the roof (figs. 52 and 53).

54

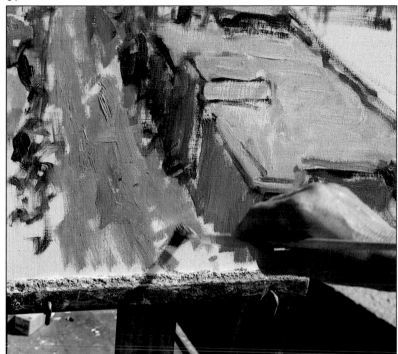

Fig. 54. As the last step in defining this low, flat building, Mangot paints its shadow on the street with a bluish tone.

Fig. 55. At this point she contrasts the area on the right (which has been worked on more) with the left side (which hasn't been totally stained). Mangot works first on the foreground and then on the sky, where she returns to mix a variety of tones directly on the canvas: crimson, blue, and yellow.

55

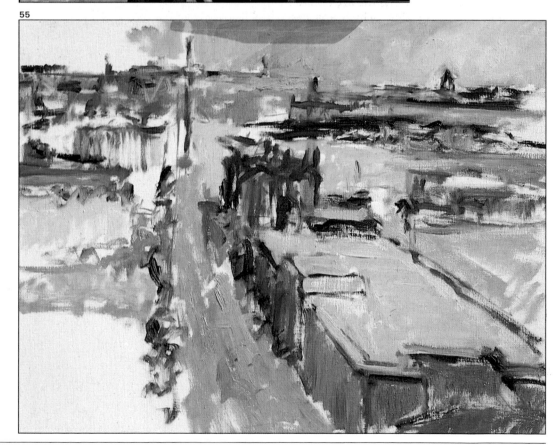

Fourth stage: defining the shapes

From this point on, Mangot finishes with a kind of sweeping over the canvas, descending from the horizon to the lower part; it's an effort to define shapes.

Now Mangot delicately holds a brush that is almost without bristles. The brush becomes involved in its path, leaving along the way little luminous impastos of clean colors: yellow, orange, and white.

This personal "pointillist" style surprises us by its capacity to suggest the various elements of the subject: the buildings on the horizon, the fishing boats in the port, the tree-lined avenue.

At this advanced stage of the painting, the canvas still has some white spaces next to the areas that are the most completed. But Mangot gets ready now to give some shape to the trees in the foreground, staining the entire canvas.

56

57

58

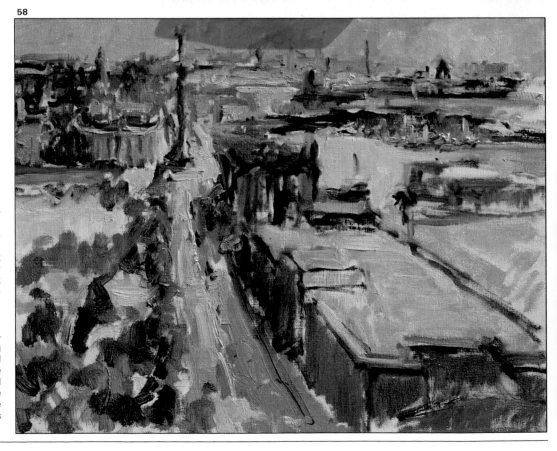

Figs. 56 and 57. Holding the brush carefully, Mangot paints highlights and shapes from the horizon to the foreground (fig. 56). Her style is reminiscent of pointillism. Using her brushes with their short points, she draws the shapes with narrow lines. (fig. 57).

Fig. 58. Mangot completes this step by painting the trees in the foreground on the left. To do this she again combines emerald green with an ultramarine and white, applying the paint with short, nervous brushstrokes.

Fifth stage: painting and repainting

Figs. 59 and 60. Mangot constantly changes color tones in important areas, like the shadow of this building (fig. 59), which was blue at first and then took on a greenish tone. Mangot's painting deals with layers of color, lines, and drawing. She's not interested in details, like the cranes at the water's edge, so she draws them with thick, decisive lines.

Mangot's paintings are about painting in general. All painters confront the problems of composition, of perspective, of synthesizing bulk with color. Abstract painters must also convey their ideas in an impulsive and original way, without losing sight of the model.

It's only in the benefit of pictorial interests of her paintings that Mangot finishes the modifications she considers necessary. In this particular case, she has decided to enlarge and slightly curve the building in the foreground, in order to open up the space and provide the subject with more depth.

And this isn't all! More interested in resolving the painting's internal problems than in looking for its direct resemblance to the model, Mangot paints and repaints over the same area, varying the colors until they acquire the illumination she is looking for. She is capable of instantly changing a bluish shadow to a greenish one that gives more light.

This continuous process of advance and retreat makes sense to Mangot: It's important to give the painting movement, because this is how it acquires a natural integrity and flow.

With four lines of light yellow, she covers a messy spot of ultramarine, constructing some buildings along the port. With some dark brushstrokes she paints a tree's trunk and branches, and then paints the cranes along the port with thick lines. Mangot uses the same brush to paint the borders of the buildings; she goes over them and gives them the expressionist touch characteristic of her painting.

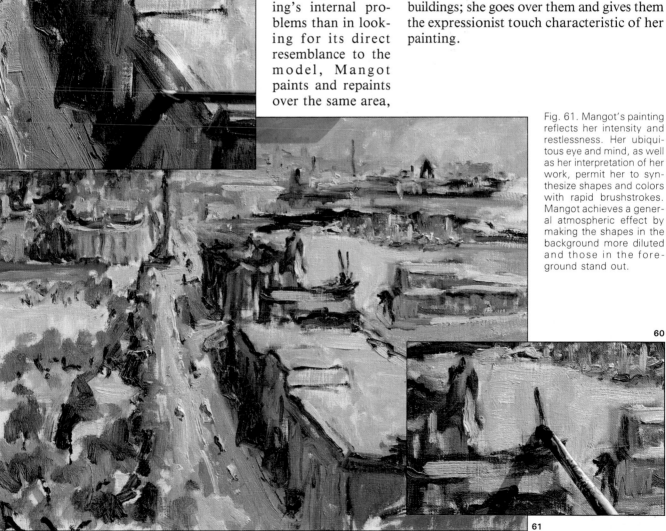

59

60

61

Fig. 61. Mangot's painting reflects her intensity and restlessness. Her ubiquitous eye and mind, as well as her interpretation of her work, permit her to synthesize shapes and colors with rapid brushstrokes. Mangot achieves a general atmospheric effect by making the shapes in the background more diluted and those in the foreground stand out.

Sixth stage: ready to finish in the studio

The outdoor session has come to an end. Mangot finishes a few details. She defines the shape of the reddish roof in the foreground and fills the empty space on the right with a new building. She also dots the avenue with cars to make it stand out more.

Oddly enough, Mangot doesn't take the paint off her brushes but rather wraps them all together in newspaper so that once in the studio she can wash them in strong detergent.

Now, a little more relaxed, she tells us how she intends to revise the painting in the studio. "I have to separate the trees in the foreground from the background and give them more space."

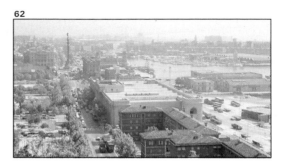

Fig. 62. We return here to a photograph of the subject so that you can appreciate the transformation that it has undergone. Reality has found new meaning on the surface of the canvas.

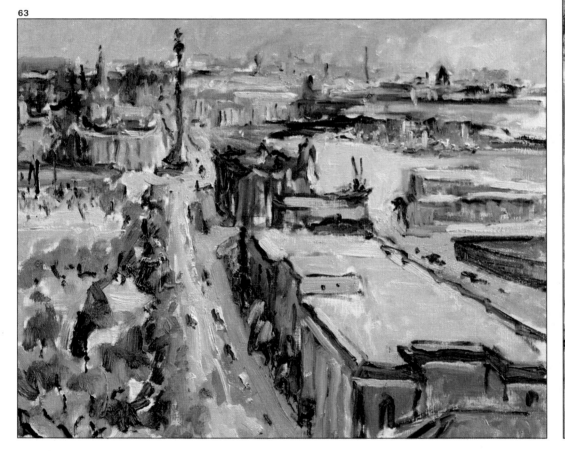

Fig. 63. Before completing the session, Mangot has redone some areas of the roofs of the buildings near the port and adjusted highlights and contrasts in the trees on the left. Nevertheless, there are some details pending, which Mangot will modify and finish in her studio.

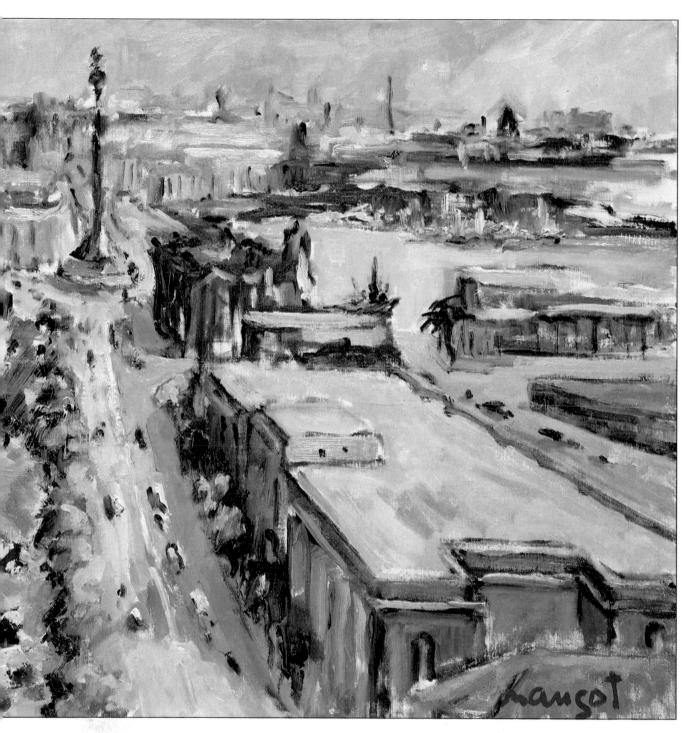

Fig. 64. As you can see from the photograph, Mangot has been very demanding with her painting, especially in the area of the trees in the foreground, where she has used a new treatment. Mangot has stained this part with short brushstrokes of ochres and yellows, taking advantage of her previous bluish greens as the base. This has increased the painting's luminosity, even if the forms have lost some definition and become more abstract.

Josep Lluís Casañé, a painter's painter

65

Josep Lluís Casañé is the painter smiling in the above photograph. He is ready to talk about his work and his opinions, to make us "feel at home" in his house, and to help us. Casañé introduces himself as a painter who has loved his work for many years and dedicates all his time to painting—which is the only thing that really matters to him and the thing he loves best. In such a profession, he declares, one depends solely on oneself. "You don't have to give explanations to anyone." At the end of the year, Casañé takes several trips through Spain and out of the country,

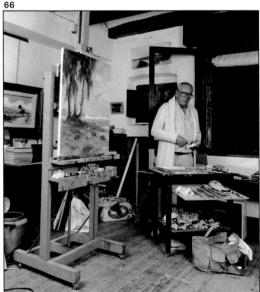

66

to paint, take photographs, and collect sketches. Right away, he shows us the results of his last trip, asking our opinions.

Casañé is preparing for some exhibits, a phenomenon not new to him. He is very used to showing his work in galleries and competitions, and on various occasions he has won prizes.

Now we are in his studio, which is in his home, a big old family house on farming property, located in a small town. It's a quiet place, surrounded by cultivated fields, open country, and bright light.

Casañé is used to painting next to a window when he paints in his studio, although he filters the light with a cloth because he doesn't like to paint with too much light. The wooden-floored studio is full of paintings. Jars of paint, turpentine, and brushes, and papers are scattered all over, as well as bags and boxes filled with tubes of paint. It's an apparent disorder, very vibrant, where Casañé moves about comfortably.

The tools he uses are typical of an oil painter. He prefers medium-size horsehair brushes, flat and round, and also uses a thick brush. Casañé tells me that sometimes he uses many brushes for one painting, and other times he resolves the painting with two or three. He also uses rags, a little jar of turpentine, and a big canvas nailed to a table with wheels. A shelf on this table allows him to have his brushes and paints handy. Figure 67 shows an example of his tools.

Figs. 65 and 66. Here is Josep Lluís Casañé, the painter who will dedicate some of his time to us. Casañé is very communicative; he tells us that he has been painting since he was very young and that this means for a long time. He was born in 1926 in the same house where he now has his studio, which you can see in the photograph. Notice also his big canvas nailed to a table with wheels; this table also has shelves where he keeps his brushes and rags handy.

Fig. 67. Casañé's supplies consist of everything that is needed to paint in oils: horsehair brushes of all types, (both flat and round, in all sizes); a little jar for turpentine; and a palette with all the corresponding colors. The palette is glass, glued to the table. The colors are: titanium white, cadmium yellow lemon, yellow ochre, cadmium red light, alizarin crimson, cadmium green light, Titan green, sky blue, light and dark ultramarine, Prussian blue, and raw sienna.

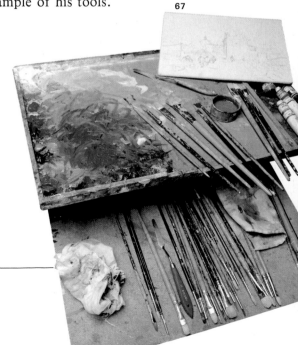

67

Above all, landscapes

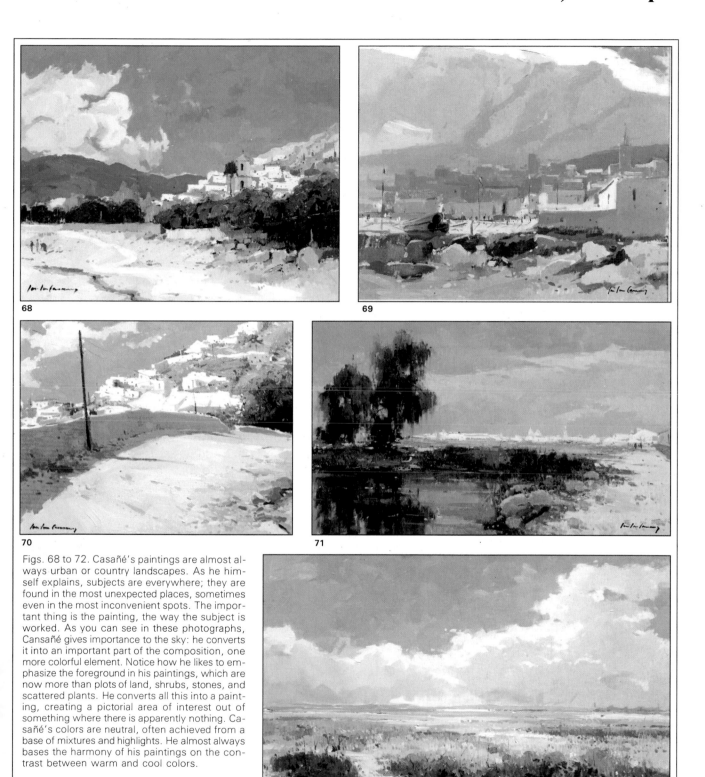

Figs. 68 to 72. Casañé's paintings are almost always urban or country landscapes. As he himself explains, subjects are everywhere; they are found in the most unexpected places, sometimes even in the most inconvenient spots. The important thing is the painting, the way the subject is worked. As you can see in these photographs, Cansañé gives importance to the sky: he converts it into an important part of the composition, one more colorful element. Notice how he likes to emphasize the foreground in his paintings, which are now more than plots of land, shrubs, stones, and scattered plants. He converts all this into a painting, creating a pictorial area of interest out of something where there is apparently nothing. Casañé's colors are neutral, often achieved from a base of mixtures and highlights. He almost always bases the harmony of his paintings on the contrast between warm and cool colors.

First stage: laying out the drawing

Casañé is going to paint an urban landscape from a sketch that he made on his recent trip south. He begins preparing a very neutral, rather dark gray, tending slightly toward blue. He mixes it with a great deal of turpentine and begins to draw on the canvas with a rather thin round brush.

He begins by drawing a horizontal line that divides the canvas in two in a very balanced way, probably near the proportions of the golden section. Buildings are located above this line, and below it is the open space that extends toward us.

The drawing is becoming constructed and defined. The theme is a wide sidewalk in Seville next to the river where there are stalls and stands from the outdoor marketplace. Casañé is attracted to the carefree Arabian spirit of buying and selling in the vivacious open spaces; he likes the luminosity of the surroundings and the vitality of the street market. A dome appears in the background, just after he explains what kind of city it is; he also draws a tower connected with the bridge that crosses the river. Casañé holds the drawing notebook in his left hand while he continues to paint with his right. He tells us that he always sketches outdoors in pencil or colored pencil, and afterward he photographs the subject. "The photographs," he says, "are simply to remember details

that in some moment may be useful for solving some part of the painting to suggest a color or a shape."

His brushstrokes are linear, soaked in turpentine, and very loose. Above all, they define the big spaces and important lines without defining the small details, and he even lets the paint drip.

Casañé decides the drawing is done. Notice the large space he left for the sky. Casañé is a painter who considers, like the impressionist Sisley, that a certain percentage of the upper part of a landscape is made up of sky. A sky well made and colored just right can highlight any landscape.

Figs. 73 and 74. Casañé begins to draw on the white canvas with a fine brush. He uses a dark dirty gray diluted with turpentine, a method that permits him to work very loosely, letting the brush slide over the canvas. It doesn't matter if the paint drips a little because it's a rough drawing that structures all the shapes at once. He begins by marking off the horizon with a line that divides the canvas in half.

73

74

Fig. 75. In this photograph we can see how Casañé consults his sketch pad, holding it with his left hand while he paints. The sketch, which he uses more for reference than anything else, is sufficiently thorough so that he can choose to include or eliminate details when it comes time to paint on the canvas.

Fig. 76. This is the end of the first stage of Casañé's painting. The composition is perfect, very balanced, and he leaves a great deal of room on the canvas for the sky. It's a sketchy drawing, linear and schematic, that calls out to be painted at once.

75

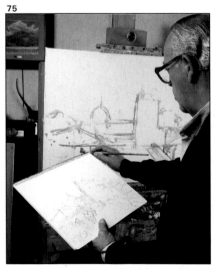

76

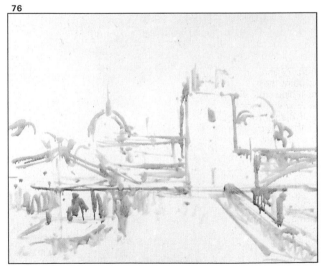

Second stage: the first areas of color

He begins by coloring the sky with a rather wide, flat brush. His colors are grays and violets, followed by a mixture of ultramarine, crimson, a dash of ochre, and white. He continuously highlights this color, since each time he gets paint off the palette, he adds a little more blue, white, and ochre. While he works on the sky, he is also drawing—reserving—shapes that pertain to the buildings.

These first applications of color are very general. They cover large areas, but they always let a little of the white canvas breathe through. The paint is smooth and full of turpentine and Casañé rubs the surface of the canvas with his brush. Therefore, lines appear—visible brushstrokes that suggest a direction (Flat stains appear only on the dome and in the shadowed side of the bridge's railing.)

Casañé's colors are neutral, continuously mixed together to get all kinds of grays. These are his mixtures:
— blue, ochre, crimson, and white
— green, crimson, and white
— ochre, green, Prussian blue, and white.

You can use these mixtures—and others, which you can complicate as much as you want—to create neutral, grayish colors.

Casañé changes his brush often, when he needs a clean one to change color or when he needs a smaller one to define a detail. Up until now he has used three or four flat brushes, ranging from numbers 8 to 12.

77
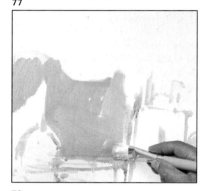

78
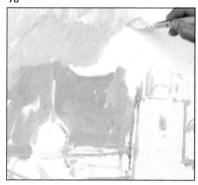

79
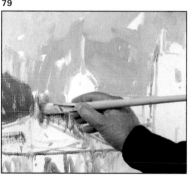

80
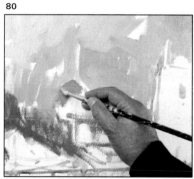

81
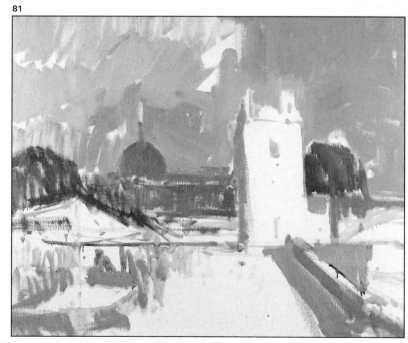

Figs. 77 and 78. He begins to paint the sky with multiple blue tints: ultramarine with white, various grays, and black. He applies all of them with a wide, flat brush, and he rubs the brush over the canvas.

Figs. 79 and 80. He continues now with green mixtures for the trees and a dark gray-blue for the dome. Casañé is still harmonizing the colors and painting with ample amounts of turpentine.

Fig. 81. By the end of this second stage, Casañé has painted a good part of the painting without stopping to consider the painting as a whole. But the painting is steadily becoming a synthesis of light and color.

Third stage: lighting and theme

82

83

Fig. 82. He paints now with more defined colors: dark blues with different highlights in the area of the market stalls. A strong contrast appears between the background and foreground, which indicates the closeness and distance of the objects. He uses this same color in the background to indicate some shadows.

Figs. 83 and 84. With a mixture of white, ochre, and yellow, Casañé gets a pale opaque color that he uses for the tower illuminated by the sun. Quickly he uses the same color over the blues in the background, suggesting steps with narrow brushstrokes.

Fig. 85. He continues with the same color, white mixed with ochre, in order to paint the sidewalk that comes toward us — toward his point of view — always with small, vertical brushstrokes, leaving white spaces.

Casañé continues coloring the parts of the canvas that haven't been painted yet. Always with medium-size brushes, he begins with the market stalls in the foreground on the left, which are scarcely drawn. These stalls and their awnings are part of the general harmony, and he paints them with dark colors, rather neutral, although less so than the grays of the sky and the buildings in the background. In other words, he paints the market stalls with pure, "clean" colors

84

85

that correspond to their position in the overall painting. Since they are the elements closest to us, their colors are not diluted; they don't "fade out" because there is less distance between them and us, the viewers.

Later he paints the tower illuminated by the sun, using light colors: mixtures of yellows and reds with quantities of white and a dash of ochre. The resulting colors don't owe all of their luminescence to white. Nevertheless, the contrast with the sky is emphatic and very adequate, since the light colors in the tower appear even lighter and more luminous against a dark grayish-blue background.

Each time he gets color from the palette, Casañé mixes a little more yellow, orange, and white. With this color, he continually highlights, covering not only the tower but also the steps in the background and the sidewalk in the foreground. He rubs rapidly with the brush, achieving a texture of straight horizontal and vertical lines that begin to indicate a tiled sidewalk. We ask Casañé if he will leave it like that (fig. 85)—if this texture is really meant to indicate tiles. Casañé answers no, that probably he will cover it, because he doesn't want to get lost in too many irrelevant details.

He keeps painting, now directly over the still-fresh paint, mixing the colors directly on the canvas. He begins to suggest volume by illuminating lights and darks. For example, in the group of trees on the left, he paints a dark green over a light green, in order to represent volume and lighting—always in a methodical and synthetic way.

He talks while he paints: "I'm making the first stain. I don't like it—I mean that I don't like to start paintings. Sometimes I wish they would give me the canvas already stained, even if badly stained." I tell him that normally, for people who are learning how to paint, the most fun is the first stain, because it is the least final and thus the most free. (In most cases, with beginners, the painting loses freshness and color as layers are added.) From Casañé's comment, one deduces his ample experience with painting. What he likes is to continue the painting—to modify it, strengthen it, highlight it—in other words, to do the difficult parts. Another aspect of his experience shows in his never focusing too long on any part of the painting, but working on all of it together. "The end is another story; then you can dedicate more time to details in one area or another of the painting."

At this moment the painting is ready for more paint. Casañé worked out the lighting of his landscape spontaneously, with direct, turpentine-soaked stains. It is reminiscent of a lesson Corot gave, recommending that his students begin by defining the lights and darks of the painting, the contrasts of lighting.

86

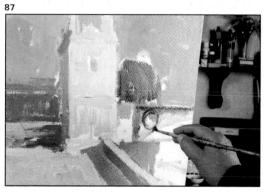

87

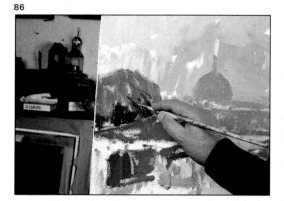

Fig. 86. Now he goes to the trees in the left side of the painting and paints blue over a previous green. The deep shadows give the trees a look of volume.

Fig. 87. With a fine brush and a dark bluish gray, he gives definite shape to the bridge near the tower on the right side of the canvas.

Fig. 88. He begins to define the shapes and colors of the marketplace. From the apparent tangle of brushstrokes, figures and tables and hanging garments begin to emerge. Everything is done with very synthetic, well-illuminated brushstrokes.

Fig. 89. In this moment, Casañé has stepped back from his painting in order to observe it carefully. We do the same. The essence of the painting, its basic composition and color balance, have been achieved. Observe the contrasting lights and darks.

88

89

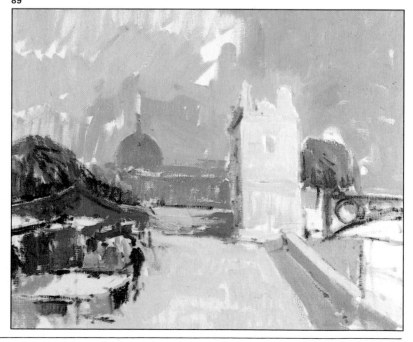

Fourth stage: defining with impastos

90

91

92

93

Figs. 90 and 91. Now Casañé is painting over the dark grays in the building in the background, and he does it with a very pale color. Later he does the opposite: With a dark blue color he paints over the light colors of the steps. This continuous process of layering constructs shapes each time with more definition.

Figs. 92 and 93. After so many mixtures of dullish, broken, highlighted colors, Casañé enters into the territory of pure color. The bright little stains—little figures—permit us to relate the larger areas of other colors. Immediately he resolves some elements in the marketplace with clean colors, layering them over previous stains.

Fig. 94. Casañé adds paint to his palette, almost all the colors he is using. He's going to begin the next phase of his painting, and he will need more supplies to cover the previous colors.

Fig. 95. He dips his brush into an ochre, adds a drop of orange, and later adds a drop of white. With this mixture he continues staining above the green of the trees. The brushstrokes are small and add bulk to the trees.

Figs. 96 and 97. With a wide, flat brush he begins to paint over the blue sky. It's a dark gray, with a little sky blue to which he adds a touch of green. Later he highlights this color, adding white and light ultramarine, and he touches up the cracks of white that show through the canvas.

Casañé has stopped painting for ten minutes. First he lit a cigarette and studied the state of his painting carefully. Next he began to look for tubes and more tubes of paint in various drawers, in leather bags, and on shelves. Now he adds much more paint to the palette, practically all the colors shown in figure 67 (page 26). This is because he's going to continue painting over the first layer, in many instances covering the previous color but letting it breathe through just the right amount. Remember, for the paint to dry well and for the colors not to mix, it's better to put a thick coat of paint over a thin one (with enough turpentine), than to do it the other way around.

With thick brushstrokes, almost white, he zigzags, across the street in the foreground. It appears even more luminous and of course much thicker. With the same flat, wide brush and with the same kind of impasto, he details some parts of the buildings in the background, painting light over dark and later dark over light. The harmony is

maintained within the previously established color range, but still he plays with lights, darks, and color contrasts.

Now Casañé begins distributing little figures throughout the space, from the vendor's stalls to the steps. He makes little dabs, very abstract, of pure colors—now at last using bright colors, reds and blues. As he says, these little dabs of bright color "give proportion" in order to make sizes and depth evident.

Intoxicated by the purity of color, he paints thick impastos in the marketplace with a fine brush.

94

Fig. 98. In its fourth stage, the painting seems almost totally resolved. The new brushstrokes are layered over the previous ones without mixing with them. Big, zigzagging brushstrokes cover the foreground, making it even more luminous and consistent. Notice also the wonderful integration of lights and darks.

The hustle and bustle of the vendors, the various objects, and the shoppers come alive with oranges, reds, ultramarine, and sky blue—all bright and well-defined colors.

He works with long, round brushes and resolves the shapes with short strokes that give substance to the trees and walls. New brushstrokes are superimposed on the previous colors.

Suddenly he changes brushes, choosing a flat, thick one, and prepares dark gray on the palette above the other colors. (You can see in figure 94 how Casañé mixes paint on his palette.) The gray he now prepares is neutral and opaque, and he uses it to cover much of the sky. Then he adds white and sky blue and continues moving the brush all around the area. The sky blue lightens the gray and turns it green. As a result, the sky is darker above the horizon. And now, let's look at the whole painting as it stands: The illuminated areas of the trees and the houses are lighter than the sky (look up to check). This often happens in very bright places, where the sunlight is very powerful. It's necessary to know how to illuminate correctly, to adjust to the relationships that occur and not to let ourselves be carried away by old beliefs (for example, that the sky is the lightest thing in the painting).

The painting is almost finished. Casañé comments, "It is necessary to give more volume to the marketplace, to strengthen the shapes and the lighting, not to leave the painting flat, gray, without depth."

95

96

97

98

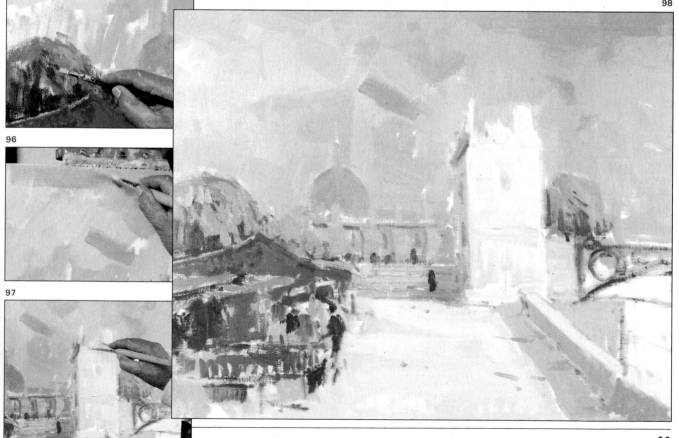

Fifth stage: the painting is almost done

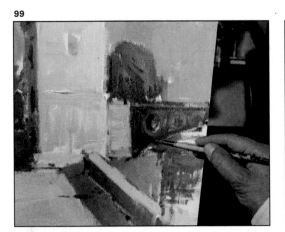

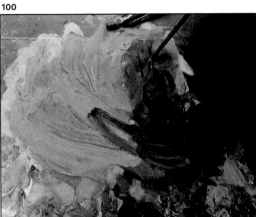

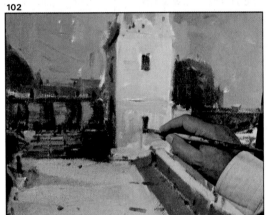

Fig. 99. Casañé works on the area of the bridge that crosses the river. He paints the shadows of this metal structure with cool, dark blue-violets.

Fig. 100. It's very interesting how this painter puts colors on his palette and mixes them. He constantly moves the brush, making drawings of intertwined strings of paint. Then he collects an unexpected color, a color that was already mixed on the palette.

Figs. 101 and 102. Better definition and construction of volume are the problems that Casañé is solving in this quiet but never still painting. Where are darks and lights missing?

Fig. 103. He now adds more pure colors to the hubbub of the street market. Dozens of little brushstrokes give feeling and unity to this area.

Casañé zigzags the brush over the palette again to gather paint and mix the colors. The shapes that the brush draws on the palette's surface are knots, intertwining snakes (see fig. 94 again). Often he doesn't even look to see whether he has picked up a color in the brush's quick coming and going—but it doesn't matter since this way the grayish mixture vibrates with new and surprising highlights.

Now he paints the Triana bridge, of this famous neighborhood in Seville, constructing its iron shapes with light and dark violets. Later he will go over the market stalls with more definition—adding darker colors, illuminating all the elements, but in a casual way. Perhaps this casualness, the constant movement of the market, its coloristic vibrations, are very appealing to a painter like Casañé who has painted this theme on sever-

al occasions. (As it happens, this theme was widely used by the impressionists, just as we explained in the introduction of this book.) The markets are part of the urban landscape—the changing, walking aspects of our towns and cities.

Now he constructs the trees in the background with grayish greens, adjusting them to the canvas's general color harmony and lighting. Casañé paints slowly but without pausing and with enormous theatricality. (At any rate, the painting evolves much faster than we would imagine from watching only the painter's movements.) He paints standing up and often backs away from the painting, especially now since he is finishing. Casañé changes his brush according to the detail: now with a fine brush loaded with ochre, he paints the arabesque, the finishing touch on the tower; now with a thick brush he delineates a shadow.

For the first time he deposits pure yellow in the market area, but immediately he mixes it with the colors underneath. He silhouettes the awnings with a raw white color, mixed with ochre, in order to show the light that illuminates the upper part of the awning and contrast it with the trees above and the dark blue below. He also works on the river area, under the bridge, which he has scarcely touched until now. The river is where the whites of the canvas still breathe, but now he covers them with brushstrokes, indicating reflections at the same time. Later he adds tiny brushstrokes all over the canvas, like notes of color that unite all the colors and make them vibrate.

Figs. 104 and 105. Casañé now moves to the only area of the painting that he has hardly touched: the river and the plant life along its banks. He paints a few trunks and branches, a little foliage. Then immediately he portrays the reflections in the dark blue water, where the sky is reflected in the river, with a very pale gray.

104

105

106
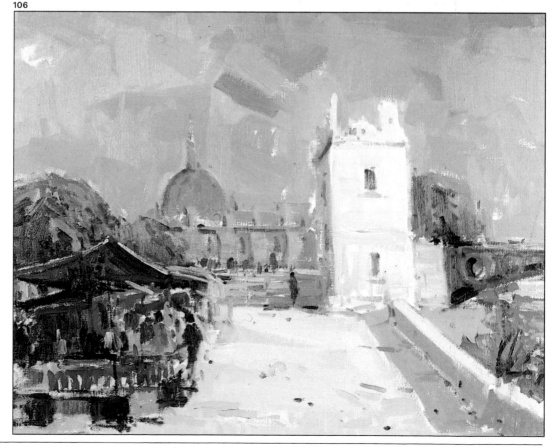

Fig. 106. This is the fifth stage of the painting, and Casañé doesn't know whether it's finished yet. The truth is that it is almost resolved. He very definitively adds the white lines that are part of the upper area of the awnings, and these little details of light and shadow help resolve the totality of the painting. Also, the little spots on the street integrate the colors even more.

The sixth and final stage: knowing when to stop

107

110

Fig. 107. Standing in front of his easel; Casañé seems to be asking the painting what's missing. He studies it as a whole. The only thing that isn't finished is the marketplace.

Figs. 108 and 109. The last brushstrokes of the painting are small and apparently not very important. But, above all, in the market stalls, these brushstrokes give final definition.

Fig. 110. When we arrive at this point, the finished painting, there is scarcely anything to say that hasn't already been said. Casañé has redrawn some elements, like the tower and the dome; and he has

redefined things that seemed flat or ambiguous. He has added warm tones over cool tones to represent reflections; this occurs in the railing that separates the sidewalk from the river. The variation of highlights is subtle, sometimes minimal. Nevertheless, the whole painting has gradually become more consistent and better balanced. The problem of finishing a painting isn't solved by resorting to unnecessary details, but rather by seeing the painting from a global perspective and trying to determine whether it still needs something, whether something seems wrong with it.

Now it's a matter of getting better quality, of adding some detail, to change a color or to soften a discordant note. While Casañé studies the painting intently, he tells us about the selection of theme, which we think is interesting for any painter. "Themes are everywhere. The theme is only the excuse; it is necessary to imagine it, interpret it. In other words, it isn't necessary to wait to see it, but rather to reflect, to think, to look for the composition and the color harmony that makes it interesting. The theme, the true theme, is the painting itself, the pictorial solution of something more or less agreeable. In a theme that we call thankless—in other words, difficult, not very picturesque—you have to truly struggle and study the problems that the painting presents." And this is what Casañé is doing now: He looks at the painting and solves the pertinent problems. At this time, these are important aspects for deciding the quality of his personal interpretation. This doesn't mean that in a previous stage the painting couldn't have been accepted as finished; on the contrary, one has to know when he must stop, when he's in danger of overloading it with details. Naturally, for Casañé this is no problem. He can leave it as it is or continue painting, without running the risk of adding superfluous details.

108

109

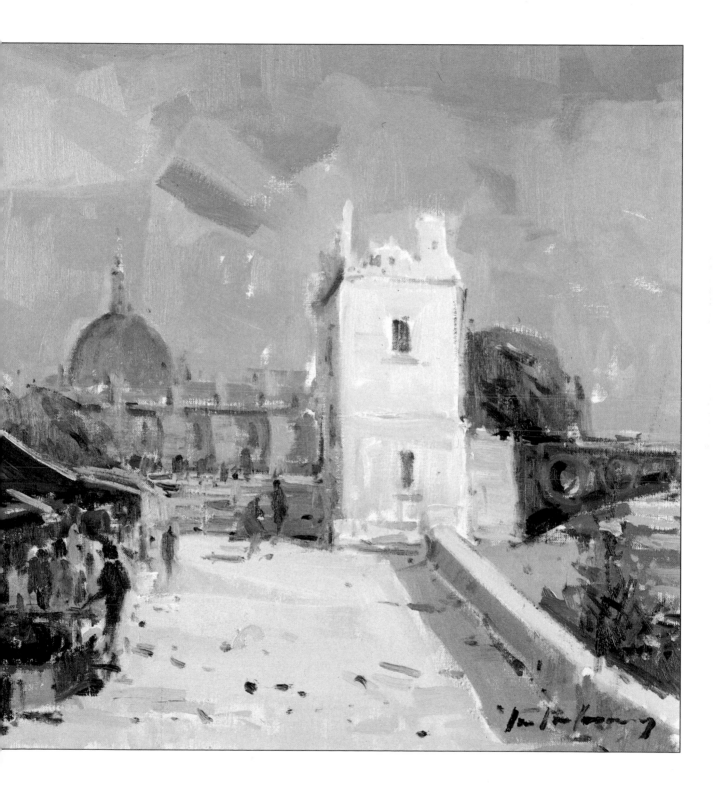

The process, the preparation, the drawing

We are in Pedro Roldán's top-floor studio, complete with materials, paintings, and photographs. We have invited this young painter—born in Cordoba in 1954—to paint a village landscape for us.

Roldán always paints in the studio, but this is the last phase of a long process: He takes sketch pads to the countryside and does rough sketches in pencil, colored felt-tipped pens, colored pencils, watercolors, or oil. He also takes photographs of his subject. Later, in the studio, he refers to all these materials while painting more involved sketches like those in figure 112. At this stage he decides on composition, color harmonies, and rhythms. After this he paints the final painting in the studio. (Sometimes he may return to the countryside again to resolve some details.)

Today, logically, he will paint a final painting from a smaller one. He will do it on wood already prepared: a two-ply board, sealed with a primer. He paints on wood because—as you will see—he uses palette knives a great deal, and the hardness of the wood permits him to emphasize and scratch. He puts strips of adhesive around the bor-

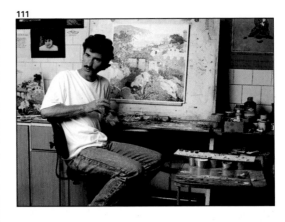

ders of the wood to reserve the edges so that the finished painting will have a finished look, framed in white.

This piece of wood is square, and you can see in the following pages that this format is typical for the artist's work. Roldán explains that, for his taste, it's very easy to work with, permitting him to create varied, pleasant compositions. The wood measures 24 × 24'' (60 × 60 cm).

Fig. 111. This is Pedro Roldán, a young painter who has lived in Barcelona since he was sixteen. He loves to escape from the city and paint his impressions of nature.

Fig. 112. We can see here two types of sketches by Roldán: the ones he does outdoors to study color and composition, and those he does in his studio, which are 4 × 4'' (10 × 10 cm) or smaller. His outdoor sketches are done with felt-tipped pen, pencil, or watercolor; his studio sketch are done with oil paint.

Fig. 113. Here are Roldán's basic supplies: a brush for priming the wood, small palette knives, flat horsehair brushes (not very wide), fine sable brushes, a pencil, and eraser. He uses the following colors: titanium white, cadmium yellow medium, cadmium orange, cadmium red, alizarin crimson, Titan green light, Titan green deep, sky blue, ultramarine, and dark violet.

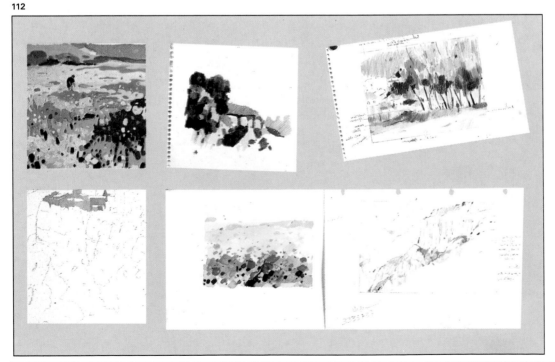

Figs. 114 and 115. In a few minutes, the wood he is going to paint on is prepared. He paints it with one or two coats of sealer, later sands it down, and uses strips of masking tape to reserve the borders of the painting.

Fig. 116. Roldán is drawing; here he uses the stick as a ruler to mark the line of the horizon on the sea. Note the exact definition on the shapes in the rest of the drawing.

Roldán paints with titanium white, cadmium yellow medium, cadmium orange, cadmium red, alizarin crimson, Titan green deep, Titan green light, sky blue, ultramarine, and dark violet. Furthermore he uses other neutral colors (like compound green and light violet) as well as transparent colors (like crimson lake and Rembrandt purple), but these last ones he uses infrequently.

Roldán's many horsehair brushes are from China. They are not too stiff, and they range from the smallest to the medium sizes, He also has a few thicker brushes. Besides this, he uses very fine sable brushes and synthetic brushes to substitute for the sable-haired. (Synthetic brushes are very cheap but they erode quickly with turpentine.) There are four or five small palette knives and a maulstick (see fig. 116), which he uses occasionally when he wants to be very precise.

The subject of the painting today is Tossa de Mar, a sunny town on the Costa Brava, with the sea in the background and a hillside full of vegetation in the foreground.

He begins to paint with fine, precise lines, using the maulstick to trace some straight lines. With a sharp white pencil he carefully indicates the shapes of the houses and the shadows.

Roldán's lines cross and are often straight, which corresponds logically to the urban landscape. These houses, like most

114

115

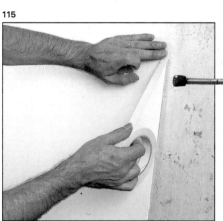

116

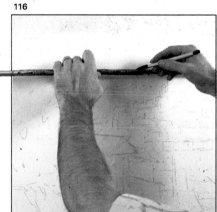

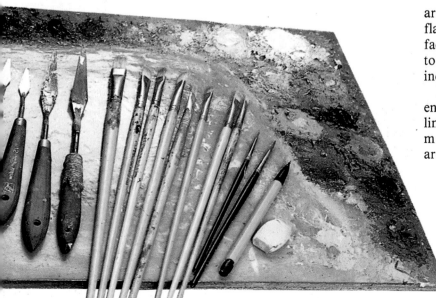

architectural forms, create an illusion of flat, superimposed vertical and inclined surfaces, so that the transition from foreground to background is broken down into the little individual units of each building.

It's interesting to note how a clear difference is already evident between the type of lines that delineate the natural forms—the mountains and vegetation—and the architectural ones—the houses.

Pedro Roldán's work

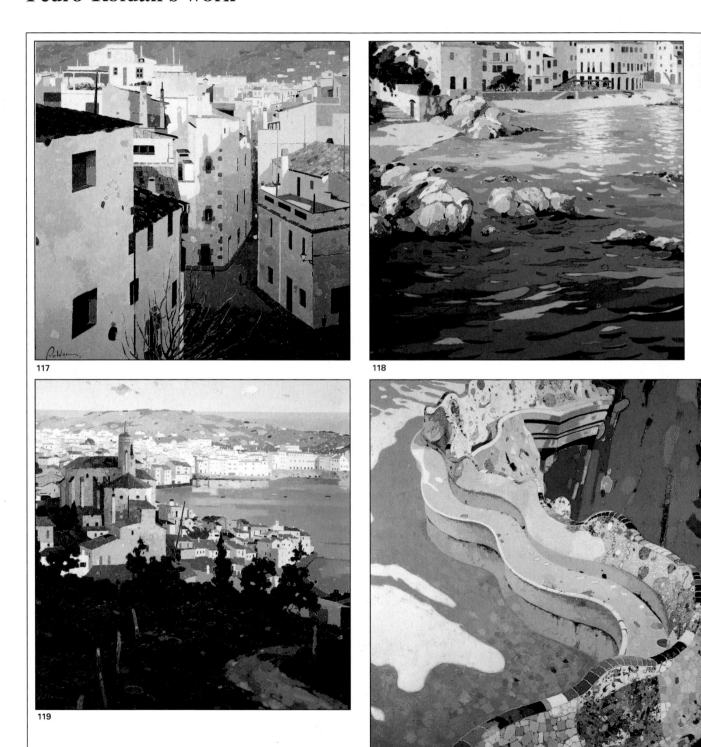

117

118

119

120

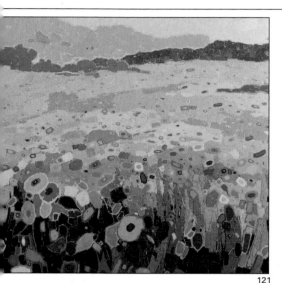

121

Figs. 117 to 123. Pedro Roldán has always been painting—at least he's been painting for as long as he can remember, since he won a national award for painting at nine years old. His style has varied as he has discovered new forms of expression. He has taught classes, won many other awards since his first one, and exhibited his work on many occasions. The paintings you see on these pages come from his last show and are a good representation of his style: a brilliant color range, meticulous and defined; an extraordinary illumination; an imagination expressed with color in a very personal way. Roldán's work is reminiscent of the caves and coves of Joaquim Mir (1873-1941), and of the postimpressionists, the expressionists, and the fauvists. The landscape theme, urban and rural, is almost always evident.

122

123

First stage: the first color goes right in the middle

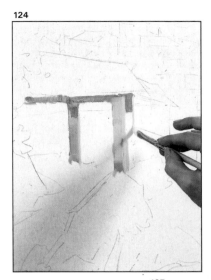

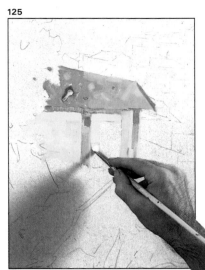

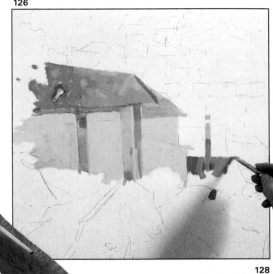

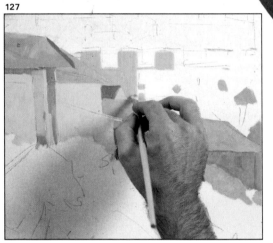

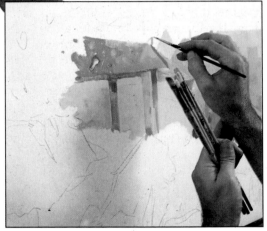

Fig. 124. He stains the walls of the houses with a flat horsehair border brush in order to outline the edges.

Fig. 125. Roldán paints slowly and fills in his drawing with very rich, warm colors, somewhat transparent.

Fig. 126. The stains have geometrical shapes. In a small area there are a multitude of highlights in nearly pure colors.

Fig. 127. With color he defines shapes exactly and later will cover them with other colors. In other words, he draws while painting.

Figs. 128 and 129. Roldán paints doors and windows in reds, oranges, and violets, preparing for the colors that he will put over them.

Roldán begins to paint the white wood, keeping his pencil drawing in mind. Nevertheless, he tells me that in reality, he is starting to draw now.

The subject's composition on the wood clearly defines the foreground, middle ground, and background. The foreground contains the vegetation and land; the middle ground contains the town; and the background contains the sky, rocks, and sea. First Roldán paints the middle ground, the town, maybe because it is the painting's center of interest and holds everything together. He tells me that later he is going to illuminate the rest of the painting based on these first color stains.

He continues slowly bringing out the objects' shapes and outlines with color. When

he paints an area with color, edges appear as lines, always geometric (rectangular, triangular) to correspond to the houses, windows, chimneys, and roofs. Just as he said, he is drawing with color.

The colors are pure and bright: yellow, light greens, oranges, pinks, ochres, and reds. In some areas these colors are modulated, for example from pink to orange in the roof's shadows, but they are also used to define more concrete shapes.

We realize immediately that Roldán paints these first colors in preparation for the later ones. He often paints with contrasting complementary colors that suggest the real look of the subject. The horsehair brushes he is working with range from numbers 4 to 12. He paints the houses farther

from his point of view with more neutral colors, again marking the boundaries of their areas while he simultaneously establishes tones and indicates depth.

The color relationships are fundamental to this painting's construction. At the moment, there seems to be little contrast because the relationships are very harmonious; nearly all the colors belong to the same warm range. Except for various neutral blue-greens that are cooler, he does nothing more than relate the rest of the tones by their complementary effect.

Roldán now paints doors and windows one by one in red, orange, and violet with a sable brush. "It's better to paint these colors in the first coat and later let them breathe through rather than paint them later. It creates a better texture, a better integration of color, a better vibration."

Now he paints the cluster of trees, which are the highest part of the town, with looser brushstrokes in blues that range from ultramarine to cerulean. He defines the trunks in red or violet with a fine round sable brush. The blue and green foliage of the trees implies that here he has conformed more to the object's reality and will later work over the trees with similar colors.

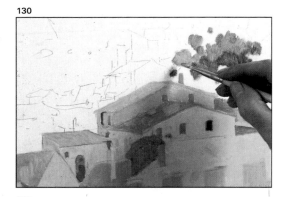
130

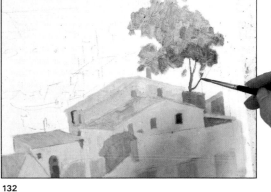
131

Figs. 130 and 131. He paints the trees above the town with loose brush-strokes, in earthy blues and greens, using ample amounts of turpentine. Later he defines the trunks with sable brushes using very fine brushstrokes.

Fig. 132. Roldán has now resolved the first coat of this section of the town, keeping in mind how it will eventually fit in with the foreground and background. Notice the warm colors, greens, and blues that blend harmoniously, very similar to the illumination he uses to unite the fragmented buildings.

132
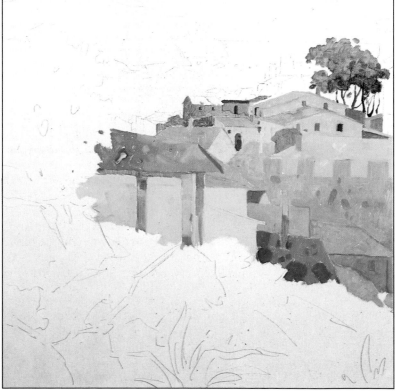

129
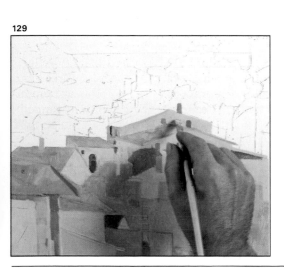

Second stage: general harmony

Roldán works in minute detail without letting the details dictate his work; rather, they are dictated by the painting itself. He matches the precise size of each window and door to an exact sense of perspective: the farther away, the smaller. In this way he creates many spatial levels, ranging from the immediate foreground to the distant background.

In other words, if we look at this painting now without thinking of what it's about, but just looking at patches of color on wood, we will see that these stains already express depth and distance by their color relationships, placement, and size. (As Maurice Denis said, "A painting, before being about a horse, a woman, or a landscape, is about a group of color stains on a canvas.")

Now Roldán begins to paint the vegetation and the land with transparent purples, greens, oranges, and pure reds. His stains are, as is natural, rounder and more organic in their shape because they correspond to live shapes.

Roldán moves his brush more quickly and loosely through the vegetation area, where he continues indicating the volume and structure of the land. It's a painting ordered within the disorder that almost always occurs in a landscape because of its expanse. A landscape typically encompasses many subjects in one: mountains, trees, buildings, stones, grassy hillsides, sky, and clouds. But in this case, the natural landscape is only an excuse—a way to explore the town's composite shapes, which occupy the center of the composition.

Figs. 133 and 134. For the little exacting details, Roldán uses the maulstick or holds one hand with the other.

Figs. 135 and 136. The light and transparent colors define all the shapes in the painting.

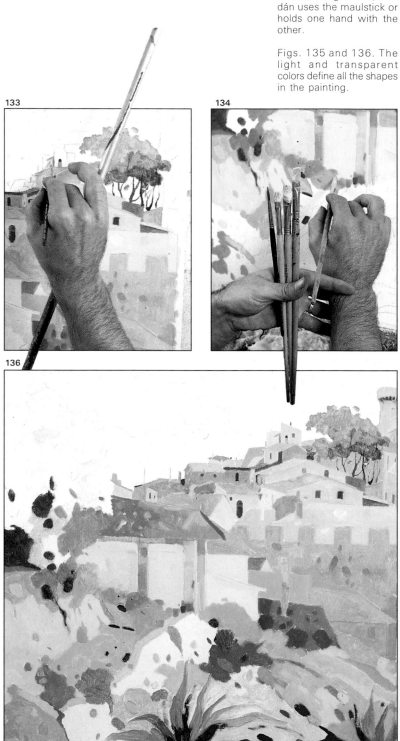

Third stage: completing the first layer

Roldán cleans his palette with a palette knife, discards the dirty paint, and wipes his palette with a rag slightly damp with turpentine. He's ready to make new mixtures of pearly colors, such as yellow with white and Rembrandt violet with white. Then he puts brushstrokes on the cliffs in the background, the area that up until now has had the most light in the whole painting.

He moves to the vegetation area that covers the distant hillside like a shawl (fig. 138) with a mixture of green and white, again a very light color. He moves on to suggest the luminous sky, which represents something similar to the painting's backlighting (fig. 139).

Roldán has stood up to paint this area and at times backs up a few steps before returning to paint these stains. The background stains are the largest in the painting, since distance unites and softens the smaller areas of color. This perception is expressed with large, neutral tints subtly softened with white.

He paints the sea in very pale pink and orange tones, lightened with a great deal of white. The sky is a slightly grayish pale yellow, painted with large brushstrokes that serve to unite the whole area by making the colors all very similar. At this time the painting is illuminated almost to perfection, but with colors opposite from reality. If a house is blue, it is painted yellow; if a plant is green, it is painted red and orange—and not just any red or yellow or orange, but the precise tint and hue that the artist has chosen in his careful, deliberate balancing of colors.

Fig. 137. Roldán paints standing up now. He concentrates on the color mixtures and the amount of turpentine he will have to add to get the texture he wants.

Figs. 138 and 139. The far background he paints with big stains in pale colors, using a wide brush and a narrow brush to make the shapes stand out, holding one hand with the other in order not to touch the area he already painted.

Fig. 140. This photograph was taken at the end of Roldán's first work session. He has painted the middle ground, then the foreground, and finally the background, adjusting color and illumination along the way, but in many cases using the opposite colors from the real colors of the subject.

138

139

140

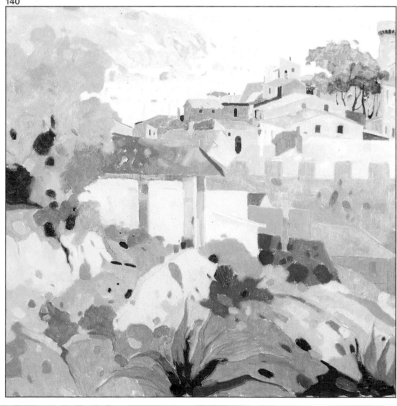

137

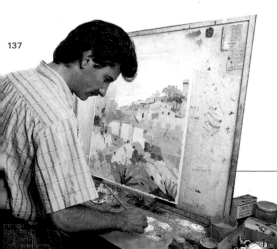

Fourth stage: colorist painting, Mediterranean painting

Besides the typical tubes of paint from all the name brands—Roldán selects them according to the colors that interest him—he uses powdered pigments that mix with tubes of oil paint. "These tubes they sell in the stores have too much linseed oil, which isn't good, especially in impastos, which is exactly what I'm going to work with this second phase. For this reason, from much experience I have achieved a texture I like by mixing oil paints with a certain quantity of pure pigment." Look at figure 143 and see how some of the colors are prepared in aluminum cups.

When Roldán stained the first and second levels of his painting, he resolved it, you will remember, with broad stains in flat shades and often inserted square, round, or rectangular little stains of intense colors: reds, greens, fuchsias, and so on.

Now, when he paints over these initial stains, he puts different colors on top of the major shapes and different colors on the little stains, and he lets both breathe. The little patches are surrounded by a silhouette of a different, sometimes complementary hue that relates it to other surrounding colors. These tiny "jewels" of color within color are reminiscent of

the painting of Gustav Klimt (1862-1918), a Viennese modernist painter with a strong decorative, coloristic, and graphic style.

In order to put on the second coat of all these colors, he uses the palette knife, never going outside of the boundaries underneath. He highlights the colors, brilliantly illuminating the darks and lights in all their warmth and transparency, whether it's a neutral violet or a bright green. Again he starts with the town, just as in the first stage, probably because it's the driest area of the painting. It must be dry so that it doesn't mix with the color on top. Clean colors, above all.

Roldán's painting is thoughtful and worked with precision. It contains passionate, brilliant colors, but they are not direct and aggressive. They make sense; they form part of a personal and intellectual decision. Roldán's use of color is reminiscent of impressionism, postimpressionism, fauvism, expressionism ... with all their interpretations of color. The paintings of Joaquim Mir particularly interest Roldán. The color and composition of Roldán's paintings of coves of the Costa Brava, the coast of Alicante, and other seascapes have something in common with the Mallorcan caves, coves, and rocks that Mir painted less than a century

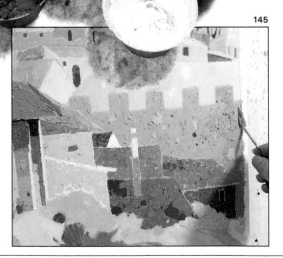

Figs. 141 to 143. For the second work session, Roldán prepares other colors besides the ones sold in tubes. Tube colors have too much oil to be suitable for impasto, so he mixes them with powdered pigments. In the photographs you can see how he mixes the color with a spatula and how he keeps it in the little cup. In figure 143 we see some colors Roldán prepared, which he will use now.

Figs. 144 and 145. He begins putting colors over the first coat, usually painting in the dry areas.

ago. Roldán explains that the feeling in his painting is a direct response to a culture and to the feeling of light and color typical of the Mediterranean.

Fig. 146. In this second coat, Roldán paints with a palette knife, pressing in little dabs of paint. In the interior of one of his original geometric paint stains, many other colors within the same range often appear, as in this case.

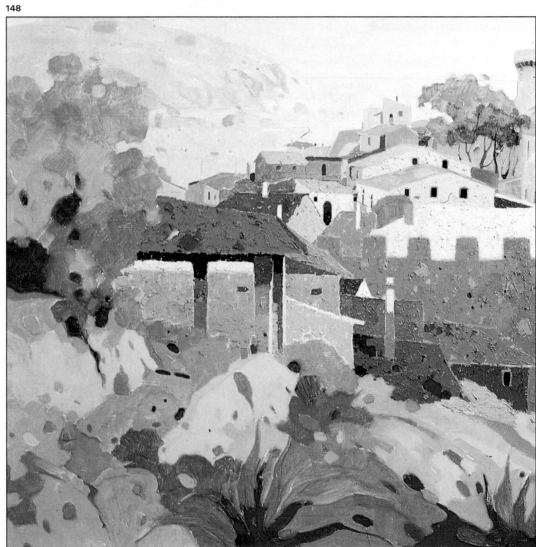

Fig. 147. For fine, detailed work, Roldán uses a sable brush and supports his hand with the maulstick.

Fig. 148. Compare this photo with the one on the previous page and you will realize that the area of the houses has changed radically. Now the colors are better adjusted and the lights and darks are almost resolved. Notice what color he has put on what color.

Fifth stage: color vibration

Roldán continues painting on the second day of work. His method produces soft color harmonies that build the structural volume of the urban landscape. Most of the town is quite well developed; all that's missing is a few rooftops and a few stains between the houses. Now the shadows are cool and neutral, but transparent and vibrant because a warmer color breathes through to let them shimmer. We see how he halfway covers the initial colors with thick impastos of paint, almost always in a complementary color. Between these impastos are small holes, now along the borders, now in the

Sometimes the artist applies a warm green over a cooler, bluish green; there is no contrast of complementary colors, but the vibrations still exist because of the contrasting temperatures of the colors.

Roldán works even more carefully in this stage than he did before. The roofs he illuminates in extremely warm colors, as if they have been heated by the sun—yet at the same time they are sufficiently grayed by the background color, each roof according to the way it's situated in space and how far it is from our point of view.

He paints down to the last details, adding

Fig. 149. In this case, Roldán paints green over green, but one is warm and one is cool.

Figs. 150 and 151. He totally resolves the trees in the town, painting the background first so that it breathes behind the trees, and later refining them with greens and impastos of all types. He finishes painting little dots of yellow and turquoise above the thick greens to give the sensation of tiny gaps in the foliage.

149

150
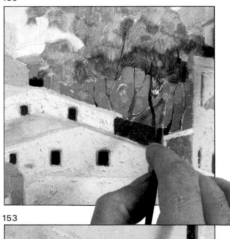

151
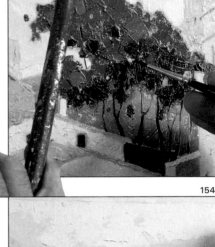

152
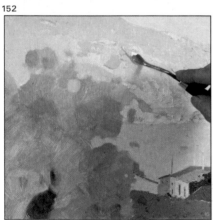

153
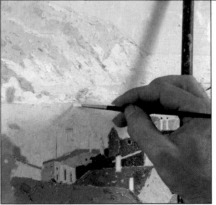

154

155

interior, and the colors that "peek" out of the impasto color produce a vibrating effect similar to that of Mediterranean light. This concept is somewhat fauvist, but it also belongs to Roldan's unique painting process and comes from his own source of motivation.

green over the little windows that have been red until now. On the trees in the town, he puts some dots of yellow and turquoise to indicate the transparencies of the leaves. These stains make up part of the last step in Roldán's work, as he tells me.

Above the pearly colors on the horizon he begins to apply impastos of others equally pale and pearly: soft yellow over the pinks in the rocks and sky blues with a little white over the greens that make up the vegetation. The effect is muted but very clear because it corresponds to the background contrasted with the backlighting in the rest of the painting.

He enriches the sea, the rocks, and the sky with gray blues, using a small palette knife to put on the paint and outline the areas. This background relates perfectly to the town, achieving a sensation of radiant summer light that glows on the freshness of a quiet sea and makes all the colors dance with dazzling clarity.

It's important to point out the pictorial texture that has appeared in the painting as a result of the impastos. Sometimes Roldán has put a different color on previous impastos, but in other places he's applied a thick layer of paint in the same color. The impasto in the almost-white sky, for example, has the kind of prominence that he wants (fig. 157).

Fig. 157. The blue tones of the distant hills are united with the tones of the sky and the sea, and contrast with the generally warmer tones at the center of the painting. Durán has continued resolving the second coat of impastos, keeping in mind the pictorial texture that he is creating. He pays attention to the outlines of some stains and also the sensation of summer light that the painting emits at this stage.

156

157

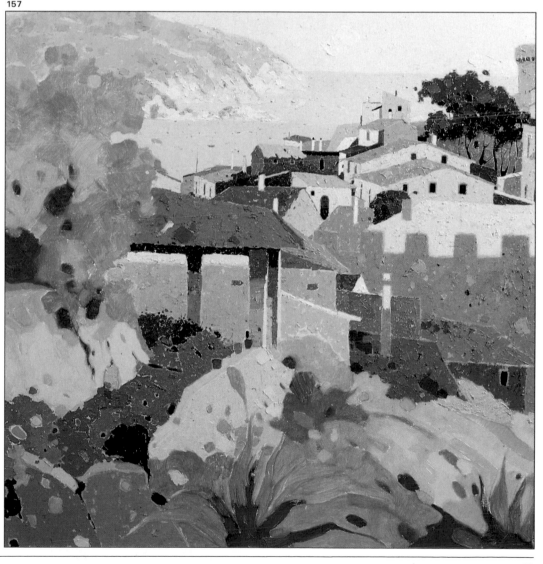

Figs. 152 to 154. He goes to the background, where he uses blue to paint the plants covering the hills. This luminous blue works very well because it is off in the distance. Later he paints the sea with a pale ultramarine, making it stand out by painting little stains and letting the pink in the background breathe through to enrich the blue.

Figs. 155 and 156. He keeps layering opposite colors with the palette knife, such as violet over orange. He paints over the smaller stains, but keeps the new color surrounded by a thin trace of the old, like little flourishes.

Sixth stage: the finished painting

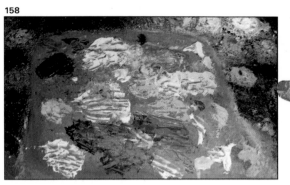

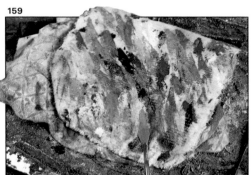

Figs. 158 and 159. Roldán is methodical, even in his cleaning. Here you see his palette again, at the end of the previous stage, and the rag he used to clean his palette knife.

Roldán likes music and always listens to it when he paints. He finds that music can successfully create the mood of a landscape or climate. He's a friendly man, without being an extrovert, and all this time we have been talking about many things: painting, landscapes, music. He is concerned with current problems such as the destruction of the environment. Roldán sometimes is able to escape from the city for a few hours, or even half an hour, just to be in a quiet place with a beautiful view or at least a place that is pleasant and relaxing.

Now he continues with the foreground, first deciding the places where he will put the darkest darks, the most intense shadows. He paints these with ultramarine mixed with green or violet, a deep color.

As he paints the trees, he suggests groups of leaves by bringing out their shadows and contrasts. Here the colors are more naturalistic: dark greens, sap greens, and bluish greens—always by areas, and always letting the background crimsons and oranges peek through here and there. The brushstrokes are more improvised, looser.

He uses dullish colors (siennas, blues, and deep browns) and finally, happy colors (green and turquoise blue, emerald green, and contrasting violets and reds) to describe the agave plant in front.

He has resolved the luminous contrasts in the foreground. A grayish light conveys the foreground forms and clarifies their relationship with the middle ground and the luminous background. The painting gives us an opening, a center of attraction (the town) and a background (the endless sea bathed in light). This is Roldán's finished painting,

Figs. 160 and 161. The last impastos are pure red over compound green, creating a strong vibration, and very pure and brilliant blues and greens over the crimsons and reds of this central agave plant. Notice how he has related these bright colors to the dull colors that surround them by using little dots of bright color.

Fig. 162. After cleaning his brushes with water, Roldán lets them dry like this on the terrace of his studio.

one from which I believe we have all learned as a result of the clarity of his method.

Nevertheless, this clarity is not in any way easy or obvious. It is a result of many years of study, of a natural ability; of an intense examination of theme in relation to color; and of a serious apprenticeship in drawing, lighting and perspective.

We have nothing more to do than congratulate Roldán and say goodbye in hopes that we will see him at some of his exhibitions.

163

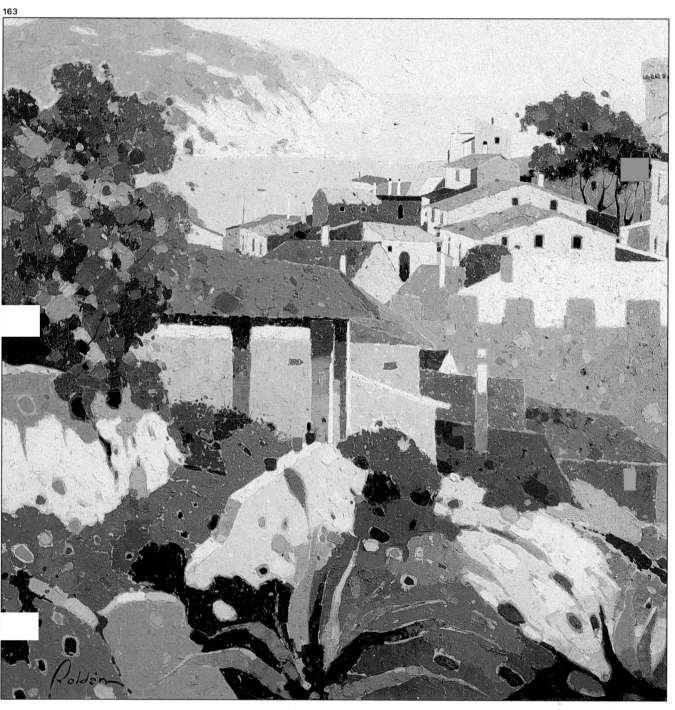

Fig. 163. Here is the final stage of the painting, which you can see is already signed. Notice the relationships among the various spatial levels from foreground to background that invite us to enter into the painting, directing our gaze toward the town and then the sea's cool luminosity. Notice also that the foreground contains the most contrast. The thick areas of vegetation, with their various impastos and dark round shadows, are not separate from the rest of the painting, but are placed next to the lightest parts of the canvas. Synthesis, colorist abstraction of the shapes and a special sensitivity to light have created a happy and interesting result. Congratulations, Roldán!

Marta Durán in her studio

Fig. 164. This is Marta Durán, the young painter who is ready to paint an urban landscape for us. She is a very nice woman who explains to us how she works; she loves painting and her enthusiasm comes across right away.

Marta Durán is a young woman with a degree in biology who used to be a high school biology teacher. But she left teaching in order to dedicate herself exclusively to painting, after having combined the two activities. She explains, "I never left drawing or painting; even when I was teaching I used to draw and paint in watercolor."

Today, Marta Durán is a genuine profes-

sional artist with a promising future. She has had several successful exhibits and won important prizes.

These days she is in her studio, preparing for one of these exhibits, and we eagerly observe no fewer than fifty paintings. They are stored on gigantic shelves, placed at different distances, so that she can arrange the paintings according to size (fig. 165). Whether or not they are framed, they will not get damaged. In this photo you can also see her studio, which is wide and well lit. It's the upper floor of the duplex where she lives. Just by looking at how she's divided her space, we can confidently assume that Durán loves her work: She has dedicated, besides her time, the brightest area of her house to her painting.

On the following page we see some of the paintings in Durán's studio. Her subjects are varied, although we can intuit a certain preference for subjects with water.

Fig. 165. This view of Marta Durán's studio shows us the shelves we were talking about where she stores her paintings, with or without frames, so they won't get damaged. She has plenty of shelves in her workshop because they are very useful for holding all kinds of objects that she needs to have within reach.

Marta Durán's work

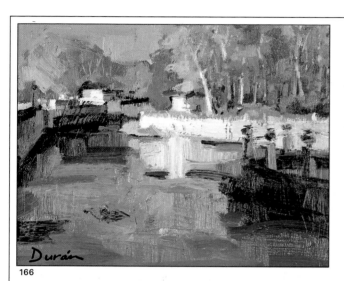

166

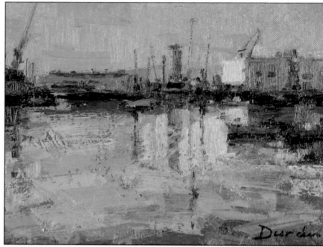

167

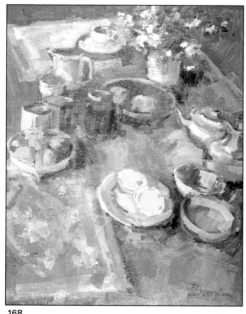

168

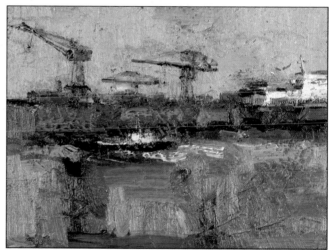

169

170

Figs. 166 to 170. Looking at these paintings helps us determine her working style. Her paintings are very carefully executed with respect to composition. The artist demonstrates a serious pictorial sense that has a powerful effect upon our eyes and our minds. She has applied a great deal of paint; she has scratched off and added on many coats. The color is almost always mixed on the palette, with a general use of grays, and the pure color stands out against the grayish base, giving the painting a sober vitality.

Another thing to notice is the type of theme that Durán prefers: seascapes, rivers, ports, themes where water occupies half or more of the composition.

First stage: painting over a primer

In figure 171 we can see a photograph of the subject that Durán is going to portray. It's a city scene reflected in the water of a canal that has a bridge across it. Some trees on the right of the canal cover the view of some of the houses, while producing scattered reflections in the water. This is a subject that the impressionists would surely have liked, since they were always motivated by the constant movement of reflections.

Durán painted a watercolor of this subject in order to familiarize herself with it, and we have photographed it in figure 172. It's a very bright watercolor that emphasizes the canal and treats the theme with unforgettable depth.

Notice in figure 173 the type of easel and the canvas prepared with a primer of grayish oil paint. Durán tells us that she paints these primers with colors left over on her palette,

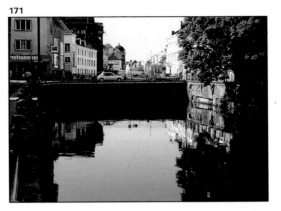

171

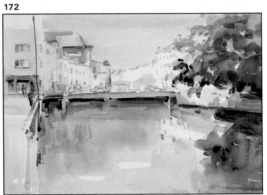

172

173

and this is why she sometimes gets a warm gray, sometimes a cool gray, or other times a greenish or reddish hue.

She begins to paint directly with a number 22 horsehair brush. She paints in a dark gray tending toward ultramarine. Notice in figures 175 to 178 how Durán takes the handle of the brush inside her hand, a method she uses when she gathers paint and mixes the color on the palette.

Immediately, when she has scarcely put on a few structural lines, she stains with neutral colors, always using large brushes. Her brushstrokes are wide, flat, and applied quickly and energetically. As a result of the paint's thickness due to its having been primed, Durán achieves special textures because she uses thick paint over a primed canvas.

Fig. 171. The urban landscape that Durán is going to interpret today is a city view with a canal instead of a street (note her love of water again) in Amsterdam. Notice the parallel perspective, the changes in sizes, and the loss of definition in the background. Keep in mind that these aspects will give the painting the sense of reality that it needs.

Fig. 172. A watercolor of the theme by Durán. The colors are light and pale, and she achieves a sensation of lights and darks by using the minimum resources.

Fig. 173. The canvas is on the easel, with the palette placed on the stool, and Durán can start whenever she wants. She has already prepared the canvas by painting it with oil paint, a mixture of colors left over from previous sessions. The canvas has a textural quality and a warm, dark gray background that Durán will take advantage of.

Fig. 174. When Durán paints in watercolor or gouache, she uses egg cartons and other food containers as receptacles and palette. It's a convenient method and very easy, so you should remember it.

174

With regard to the priming of canvases, Durán explains that she has many canvases already prepared with dark and light grays, warms and cools, and in the moment of selection she looks for a surface that will be in harmony with her subject. For example, in this painting, Durán has prepared the canvas with a warm dark gray primer, adding a little English red in harmony with the colors the subject offers in the top left corner.

After the first stains of gray colors, she superimposes those colors with thick, very light and bright yellow impastos. The impastos allow her to reconstruct over the painted area without dirtying the color. She paints with a thick brush loaded with paint, so that the color doesn't mix with what is underneath. And the painting, from all the stains applied, is already drawn and laid out.

Figs. 175 and 176. Notice in these photographs where Durán begins to paint: in the middle, drawing the composition's most important line, the one that horizontally divides the subject. Notice also how she holds the brush for painting, mixing, and collecting paint on her palette.

Figs. 177 and 178. A flat, very thick brush allows Durán to paint these big brushstrokes with luminous colors which stand out against the gray background. The brushstrokes are a result, in part, of the type of brush the artist uses.

Fig. 179. This photograph shows us the complete painting at this moment. Durán has drawn, but at the same time painted, the lines that define the subject's most characteristic shapes. She has separated the part that belongs to the city itself, indicated the trees on the right, and even begun to paint the reflection of the trees and the wall on the water. More than defining colors, she decides shapes and spaces.

175

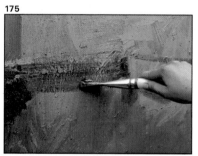

176

177

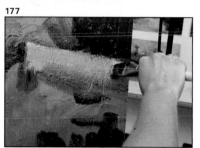

178

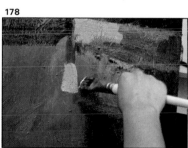

179

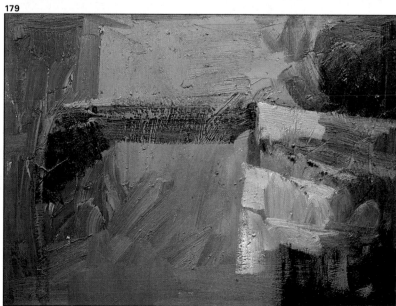

Second stage: defining with contrast

Durán paints quickly now, resolving the painting with wide stains and defined edges. A good portion of the drawing is now clear: houses, trees, bridge. But let's go step by step, although it's difficult because the artist applies color very quickly. She scrapes, she mixes, she applies again. She continues painting the walls of the illuminated houses with light colors, cadmium yellow medium or lemon yellow with a good amount of white. These pale colors stand out vividly on the dark gray background.

Later she paints a very white line with a blunt brush to represent the bridge that crosses the composition. And immediately, responding to the canvas, she uses a large blue stain (a mixture of Prussian blue, white, and a complementary color in small quantity) and covers a part of the red primer that was on the left side. Nevertheless, she always lets the color below breathe through a little—red in this case—probably in order to achieve more vibration among the colors, but also to allow for future reflections that will appear on the canvas. She has also painted some smaller, haphazard stains among the trees in ochres, yellows, and greens she gets by mixing these colors with ultramarine. And immediately she takes advantage of the greens to add a touch to the water in that area, beginning to indicate reflection.

She paints light grays in the sky and defines some of the buildings by painting their shadowed sides with dull violet colors.

180

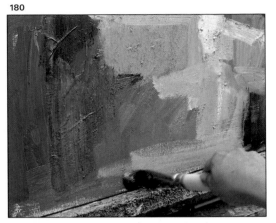

181

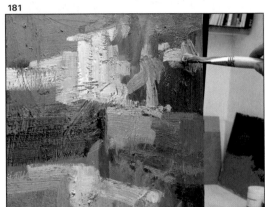

182

Fig. 180. Durán begins to paint the area that corresponds to the canal with Prussian blue and white, just above the red stain in the background. She doesn't cover it completely, allowing for red reflections to come out in this part.

Fig. 181. Immediately she changes brushes, taking a thinner one in order to paint yellow highlights in the area of the buildings and the trees on the right side. The brushstrokes are very flat for the houses, and less controlled among the vegetation, but she always keeps the construction of the treetops in mind.

Fig. 182. She loads the same brush with pure white and drags it on its side to indicate the line of the bridge that crosses the canal.

Figs. 183 and 184. Durán continues working on the houses with her thick edging brush: the illuminated ones with pale yellows, and those in the shade with gray-violet colors.

183

184

From time to time Durán cleans her overloaded palette with a trowel-shaped palette knife. Notice in the photo how Durán cleans the palette and accumulates the leftovers on one side. "This leftover paint," explains Durán, "I will use later to prepare and prime the surfaces of the canvases."

The cleaning of the palette is not very exact, and surely it doesn't matter to Durán if some leftover paint remains, since in this way she gets varied mixtures that are always different. In the middle of her creative fever, the artist paints mixing colors directly on the canvas. With the same palette knife, she erases and scrapes an already painted area and once again applies paint. She repeats this process often, always with decision.

In order to clean her brushes and palette knife she uses newspapers and occasionally some cotton rags. White paint, which she uses in large quantity, she takes out of a jar; tubes empty too quickly for her.

The painting has a very interesting texture, composed of thick impastos and flat stains, scratched or scored, with tiny gaps where the primer below can still be seen. Durán moves her brushes all over the canvas, and if she hasn't painted this red area on the left it's because this color will form part of the final resolution and she wants to keep it in order to harmonize with the colors of the rest of the painting.

Figs. 185 to 187. In these three photographs we can see how the artist uses a flat palette knife shaped like a bricklayer's trowel. She scrapes paint off part of the sky, letting the colors of the background through in order to create an atmosphere. She also scrapes the mixtures on the palette; whatever is left over she puts to the side and will use to prime future canvases.

185

186

187

188

Fig. 188. Study Durán's painting at this stage. By squinting your eyes a little, or even without doing so, you will find that she has almost resolved the painting's composition. This she has done quickly, as if sketching. Everything has been indicated, suggested: shadows, light, bulk, depth. The general tone of the painting is warm with many contrasts. The texture is an important factor too: The brushstrokes are flat, big, and not very detailed.

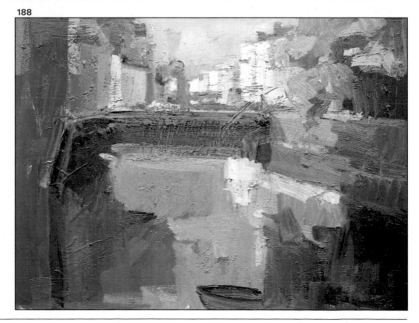

Third stage: colors, brushes, and impastos

Fig. 189. In this photograph you can see how Durán holds the brushes that she uses for this painting. Her brushes (numbers 8, 10, and 22) are flat and very wide. The two that she isn't using at this moment are held in the fingers of her left hand, separated so that they don't get stained.

In the meantime, Marta Durán takes a brief step back from her painting and looks at it from a distance, squinting her eyes in order to evaluate the lighting and see the painting as a whole. We can stop to observe what materials she uses and how she uses them.

Durán uses Eterna flat horsehair brushes, Chinese brushes that range in size from number 2 to number 12. In other words, these are her narrow and medium brushes. The thick brushes that the artist uses beginning with number 14 are da Vinci.

We watch Durán get ready to paint after her overall look at the painting. Look at figure 189: she holds two brushes in her left hand while she paints with a third held in her right. These three brushes, numbers 8, 10, and 12, are those that the artist uses for today's work.

She begins to paint on the left side of the canvas, finally addressing the red area that up until now has hardly been touched. She uses dull but warm colors: ochres, cadmium orange, crimson, and so on. Some large, decisive brushstrokes in a dullish pink-violet tone define the house situated to the left of the canvas. At once she prepares a cooler violet, with which she stains the area that represents the street on the left side of the canal.

On many occasions, we see how she paints or prepares a dark background and later uses thick impastos, applied with a large brush, to repaint and redraw over this background with lighter colors. This method enhances contrast and color vibration. In this way, she works on the reflections of the house, with oranges and crimsons over the dark blues.

Figs. 190 and 191. Durán's supplies include a palette knife and a round palette that she places on a stool, holding the following colors: cadmium orange, gold ochre, yellow ochre, cadmium yellow medium, titanium white, dark ultramarine, Prussian blue, alizarin crimson, English red, and ivory black. Her horsehair brushes we have already seen; a cup of turpentine hangs from the easel as seen in figure 191.

Figs. 192 and 193. These photos hardly need any explanation; we can just say that Durán paints light colors over dark with big brushstrokes, looking for contrast, resolving the color stains and quickly passing from the house to its reflection in the water. Notice also the distinct positions of the brush over the canvas; the artist forces the hairs of the brush to move according to the shape of the brushstroke that she wants to paint.

Fig. 194. Durán has worked on the left side of the canvas, covering the English red background and loosely indicating the shape of the house and the edge of the street. Major changes have taken place in the area of the water: the reflections are much more highlighted now, and balanced after a continuous process of putting on and taking off paint.

Durán paints standing up. Her style demands that sometimes she add more paint to her palette since she uses so much of it. She uses a round palette that she places on a stool in front of the easel. From top bottom, her colors are: cadmium orange, gold ochre, yellow ochre, cadmium yellow medium, titanium white, dark ultramarine, Prussian blue, alizarin crimson, English red, red ivory black. Durán uses an aluminum kitchen cup for turpentine, with a handle that permits her to hang it on the end of the easel's tray.

You can see in the adjoining figures how Durán drags a loaded brush over previous colors without worrying in some cases if the paint mixes a little with what's underneath. This helps her create an infinite number of highlights, and of warm and cold grays.

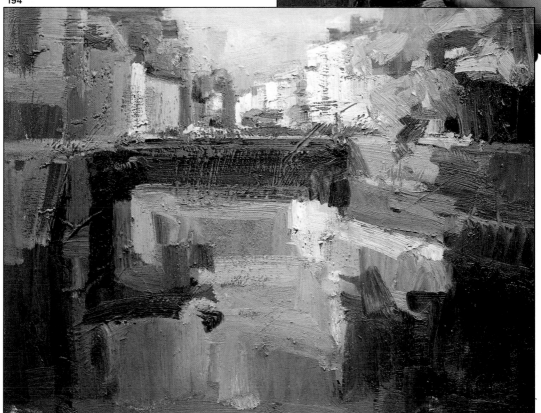

Fourth stage: interpretation

As we have seen in previous pictures, Durán paints with thick brushes ''in order not to get lost in little details.'' She paints and draws simultaneously by superimposing paint in an organized way, but with an apparent lack of preoccupation, in order not to fall into the trap of having her outlines too defined. Also, when the edge or outline of a shape suggests an excessive definition, Durán destroys it so that she can get closer to the impressionistic synthesis to which her style responds.

After staining the left side, which is in the shadow of the painting, she returns to the opposite side to resolve the shapes, tones, and lighting of this warmer, more luminous area. All the shapes on the right side continue to unite because the houses and trees are close to each other—and many are also far from our point of view.

She isn't accustomed to painting with her fingers, but in certain specific instances Durán uses her thumb to correct a small shape, as you can see in figure 199. Without letting go of the brush, she uses her fingers to redefine the relationship between the houses and the sky. Immediately she returns to the water's reflection, adjusting colors and shapes. Like all good artists, Durán doesn't stay in one part of the painting until it's done; she paints everything at once.

She also moves quickly. First she fills her brush with a very dark color and makes a small but decisive angular brushstroke to represent a shadow. Then she fills the brush again with a warm gray (a mixture of ochre, blue, and white) and paints more reflections with big stains; next she adds more blue and makes another horizontal stroke. Afterward she resolves definite shapes of the buildings on the left side with little lines done with a number 8 brush, painting sideways, to represent windows and projections.

195

196

197

198

Fig. 195. Durán takes paint off with the palette knife and at the same time achieves new subtleties of tone among the reflections.

Fig. 196. Immediately afterward, she begins to paint above these reflections, now insinuating a shadow to represent the canal wall. She does it with a dark, round, angular brushstroke.

Figs. 197 and 198. Durán continues resolving and highlighting the reflections in the water, using a grayer blue and very decisive horizontal brushstrokes.

Durán explains that she uses gold ochre (a color that was on her palette in the beginning of the painting), but she eliminated it because she thought it was dirtying the other colors. Ochre works wonderfully in mixtures, but it can make other colors excessively gray.

Durán is struggling with the reflections in the water—constructing and reconstructing, erasing and repainting, scratching with the palette knife, mixing on the canvas—until she decides to go to the other side of the painting, and return later when she can see more clearly what's missing. "It's a question of interpretation," she says. "The subject doesn't say exactly how things must be, and even less so in the case of the reflections, since the water collects all the changes of light and air. For this reason, one has to invent to arrive at a personal vision, an interpretation."

Durán puts cadmium yellow medium on her palette and says, "I put this yellow on awhile ago and used it up. I didn't want to bother stopping painting to put more of it on my palette, so I've been painting without it. But now I miss it." It's something that happens frequently to all painters.

We stop to look at the painting, which is almost finished.

Figs. 199 and 200. Later she spends time defining the buildings more precisely; she uses her finger to erase and smudge the colors, creating atmosphere. She also uses the edging brush to paint little stains representing windows, in order to highlight the color in the walls.

199

200

201
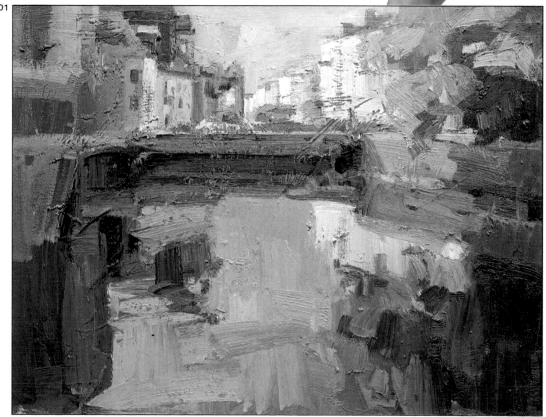

Fig. 201. At this stage the painting is almost finished. You can see the result of the continuous doing, undoing, and redoing. Compare the highlighted area with the photographs on previous pages and see how it has changed; some colors appear, some disappear, and the strokes change direction. The painting has been built up; it has depth, the elements fill in the space, and light enters among the buildings softly.

Fifth and last stage: doing, undoing, redoing

202

203

205

Figs. 202 and 203. These two photographs were taken a few seconds apart. They show how Durán automatically transfers the color she has just put in the building directly into the water.

Fig. 204. Durán is working on the details, no less important than anything else. This pale yellow strip of bright light situated over the violet serves as a contrast in color and illumination, as you can see better in figure 205.

Now she paints on the left side of the painting, defining the shapes of the houses or buildings, and the colors of these shapes move in an almost automatic fashion to the reflections in the water. She maintains the warm tendency in the color harmony but adjusts it each time to fit the subject better.

In these final moments, Durán uses not only her thumb, but her index finger. Carefully she constructs a shop on the street level whose walls are red. She paints brushstroke by brushstroke, observing and studying the effect of each color, each line, each stain.

She also paints and draws shapes in the painting that are not very refined. "I like this solution that almost seems abstract," she states.

Her brushstrokes continue to be wide and flat, very vertical and horizontal. Over the previously painted background, she paints a window and emphasizes it with four rectangular brushstrokes. She adjusts its proportions, letting the background color breathe through.

Looking at her paintings, one would say that she is an artist who paints and resolves shapes "on the spot," spontaneously. But no. Although Durán paints with a rapid brushstroke and brilliant results, this comes with the labor of doing and redoing, within this loose and vigorous language. Here, in the wall of this house, for example, she puts pure color into the windows and doors after painting the background color. "No, it hasn't been incorporated yet into the harmony of the painting as a whole," says Durán; and she doesn't hesitate to begin again, almost ignoring the background stains.

And this is the final result: a complete painting, a good painting. All the artist's scratching and adding, taking off and putting on, mixing and superimposing are all integrated. Marta Durán gives herself to the painting, and the painting—as you yourself can judge—responds very well.

Fig. 205. This is the finished painting, the painting whose progress we have followed. Marta Durán's painting process has been laborious, concentrated, and varied. Notice how she illuminates the subject in this painting: contrasting color and illumination, light yellows over violet-grays, crimsons, or blues. Notice how the colors dilute and transform in the water, becoming even more subtle. At the last moment, Durán has added a figure on the sidewalk and some cars crossing the bridge. These elements show proportion and distances in the landscape. This loosely done painting with its thick pictorial texture was quickly executed but with elaborate attention. We appreciate having had the opportunity to be with Marta Durán while she worked.

Contents